HOW TO PAINT DIVING DUCKS

A Guide to Materials, Tools, and Technique

David Mohrhardt

Stackpole Books

Published by
STACKPOLE BOOKS
Cameron and Kelker Streets
P.O. Box 1831
Harrisburg, PA 17105

First Edition

10 9 8 7 6 5 4 3 2 1

Cover and series design by Tracy Patterson

Library of Congress Cataloging-in-Publication Data

Mohrhardt, David.
 How to paint diving ducks: a guide to materials, tools, and
technique / David Mohrhardt. — 1st ed.
 p. cm.
 Includes bibliographical references.
 ISBN 0–8117–3011–5 :
 1. Ducks in art. 2. Artists' materials. 2. Artists' tools.
 4. Painting—Technique. I. Title.
ND1380.M6 1991
751.4′2—dc20 90–38134
 CIP

Printed in Hong Kong

To Deanita, Whitney, Brant, and Elicca

Contents

Introduction

 A duck sits placidly on the water, then suddenly disappears beneath the surface only to reappear a short time later some distance from where it was floating before. This is a diving duck exhibiting its typical feeding behavior, diving to feed on submerged plants or shellfish, or in the case of mergansers, to feed on small fish. Diving ducks can dive to depths of one hundred feet or more and usually stay underwater for thirty to forty seconds depending on the species. Because they dive for their food, they are not restricted to shallow water but instead prefer large open areas of water. A common sight, especially in winter, is a large gathering, or raft, of divers far offshore on their feeding waters. You might imagine that such a large group of ducks would be a noisy gathering, but such is not the case. Divers are usually very quiet except during mating season when they call frequently.

Not only does diving for food make them unique, but some divers have an unusual method of taking off from the water. Divers' wings are small in proportion to their body weight so most are unable to spring into flight as do dabbling ducks. Instead, divers must run or patter across the water surface and flap their wings to become airborne.

With some variation between species most diving ducks are characterized as having short wings and chunky bodies. There is one exception, however—the mergansers. Their bodies are longer and more slender on the water and their bill is quite different from a "normal" duck bill because it evolved to catch fish rather than eat plants. Despite these differences, mergansers are members of the diving duck family. Female mergansers are similar in form to the males, but are not as brightly colored. This is true of all female diving ducks: although they share the basic body shape of the males, the females are rather drab in overall coloration; in most instances they lack even the distinct feather patterns found in female dabbling ducks. But this doesn't mean painting female divers is easy. Subtle color transitions and muted coloration make them difficult to paint. Male diving ducks, on the other hand, are distinctively colored and patterned, which makes them easier to identify and to separate the feather groups. Thus, the emphasis here will be on painting male divers. This book will help you choose the proper materials and tools and will show you the techniques necessary to reproduce the colors and patterns found in diving ducks.

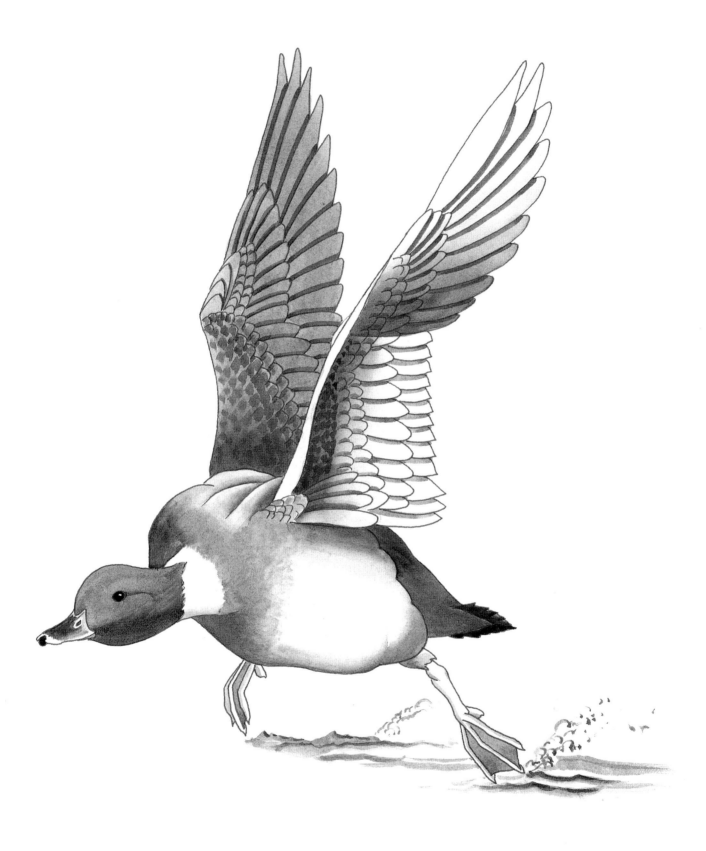

1
Painting
Mediums

 Many mediums may be used in bird painting. There are two, however—gouache (opaque watercolor, designers colors) and acrylics—that are used more frequently and with greater success by most wildlife artists. These two mediums are dissimilar in some respects but alike in others. Both are water soluble, have good covering ability, dry rapidly, and may be used opaquely or transparently.

Oil paints and transparent watercolors are beautiful mediums, but they do not lend themselves easily to bird painting. Oils require oil solvents as a thinner, are thick to work with, and dry quite slowly. They may be used thinly, but this technique requires a great deal of experience. The newer water-based "oil" paints are thinned by water but work in a manner similar to traditional oils. Conversely, transparent watercolors are applied very thinly and dry quickly. Their great disadvantage is their inherent transparency, which means that it is hard to cover one color with another, and mistakes are difficult to correct.

A word of caution here: whichever medium you choose to work in, remember that many of the pigments used are toxic or carcinogenic in one degree or another. This does not mean that under normal conditions painting is hazardous to your health; it means that you should use common sense. After painting, wash your hands before eating or smoking, or any time there is excess paint on your hands, because some toxic materials may be absorbed through the skin. And *never* point your brush by putting it in your mouth.

You can purchase a wide variety of premixed colors, but it is wise to get only a few basic ones (red, yellow, blue, green, black, white, raw umber, burnt sienna), work with them, and then buy additional colors as needed. Whether you are a beginner or an expert, painting is easier with a limited palette.

Color mixing in any medium is almost an art in itself. It is best to familiarize yourself with the basics of colors and color mixing by getting a beginner's book on color theory and then experimenting, blending colors to obtain the best results. When you obtain a desired color, either while experimenting or while involved in a painting, make a note of which colors were mixed to obtain that color. Never trust your memory; later you may try to duplicate a particular color and be unsuccessful. Making color notes is tedious but worthwhile.

Gouache

Gouache is the easiest medium to work with because of its forgiving qualities; its opaqueness allows mistakes and corrections to be made and the paint remains workable even when dry, permitting you to blend and scrub out colors.

Gouache may be used thinly to give a very transparent color, layers of color may be built up, or it may be used in a completely opaque manner with darks over lights, or vice versa. Whichever effect you choose, it is accomplished by adding water to the concentrated pigment. Gouache should not be used too thickly, however, or it will crack.

Dry gouache paint has a matte, nonglossy finish and great visual weight. It is available in a wide variety of colors but, as with most pigments, the degree of *light-fastness* (permanence) can vary widely. Most color charts have a key that indicates the light-fastness of the various colors. The ratings

are: Excellent (E), Very Good (V), Good (G), and Fugitive (F). For art that is to last, never use any colors below the Very Good rating.

Not only does the permanence of color vary, but same-named colors from different manufacturers can have very different color values, especially in the earth tones. Familiarize yourself with the color differences between the brands by looking at color charts, which are available free or at a nominal cost from the manufacturers or art-supply stores, then choose the colors and brands with which you are most comfortable.

When you look at the color charts you will notice the great variety of the basic colors, (reds, yellows, blues, and so on), but don't ignore the blacks, which have their own color characteristics. *Ivory* (bone) *black* has a brownish tone, *lamp black* has a bluish tone, and *mars* (jet) *black* is a deep velvet black. When mixed with other colors or white they can give very different results.

Gouache may be purchased in tubes, cakes, or jars. Tube gouache is the most readily available. Paints in tubes and jars remain workable over a long period of time as long as the caps are kept securely in place. The key is to keep air away from the paint, especially in tubes where the paint is more viscous than in jars or cakes. After squeezing paint from a tube, whether transparent watercolor, oil, acrylic, or gouache, never squeeze the sides of the tube to suck the paint back in—this only allows excess air into the tube and accelerates drying in the tube. With gouache and acrylics, it is advisable to put the colors on the palette only as you need them because they will dry out on the palette. Gouache may be worked when dry, but acrylic will dry completely, rendering it useless.

A shortcoming of gouache is that because it remains water-soluble even when dry, it is possible for one color already painted to bleed into a second color applied over it, if the second color is worked too much with the brush. Even when dry, the surface of gouache will rub off slightly with vigorous movement, so it is advisable to place a small piece of paper under that part of your hand that is touching the art so that traces of color already applied are not picked up and dragged around.

Despite the minor disadvantages of gouache, it is still the most versatile and easiest medium to use in bird painting on flat surfaces and is the choice of beginners and experts alike.

Gouache Mediums

Gum arabic is the basic binder used in the manufacture of gouache. It is also used, in small quantities, to increase the transparency of gouache and impart a slight gloss to the normally matte finish. It is most commonly available in small jars.

Ox gall is made from the bladder of oxen. This natural wetting agent is the best material to increase the uniform flow of gouache, particularly in washes. Only small amounts are used, and it is available in small jars.

Acrylics

As mentioned previously, gouache and acrylic have much in common: rapid drying time, water solubility, opaque or transparent use. But there the major similarities end. Although acrylics and gouache are both suitable for

painting on flat surfaces, acrylics are best for painting birds in the round, whether wood or clay. The basic color selection of acrylic colors is not as broad as that for gouache, and acrylics are only available in tubes and jars. Again, color charts should be consulted to familiarize yourself with the colors available. The consistency of paint between tubes and jars is quite different; the paint in jars is less viscous and easier to thin to a flowing or brushing consistency.

One of the difficulties that a beginner encounters is achieving the proper working consistency for acrylics. Whereas gouache cannot be used thickly, acrylic may be used from a transparent wash to a thick impasto; obviously, the working consistencies can vary widely. A rather disconcerting quality of acrylics, especially for beginners, is that even though they may appear opaque and dense on the palette, they work very thinly on the painting surface so it may take two or three applications of color to achieve a solid color, if indeed that is your intent.

The short drying time of acrylic paints cannot be overemphasized. When acrylics dry, they are *dry*; they become extremely hard and are not water-soluble. This means that wet-in-wet blending between colors must be done while the paints are still workable. A blended or shaded effect may be achieved, however, if a graded wash is put on over an already dry color (see Techniques). The hard nonsoluble surface is a distinct advantage when applying glazes (thin washes of other colors) or other solid colors over an already painted surface because the paints will not bleed into one another. The surface of dry acrylics will not rub off, thus your painting hand won't drag colors around.

Acrylics have excellent permanence and may be used on virtually any surface. A ground coat of gesso is necessary on many surfaces, especially canvas, wood, and clay. The colors have great visual weight and look juicier and brighter than gouache; the surface of the dry paint has a slight sheen.

The big cautionary note for acrylics is that, because of their rapid and hard drying qualities, care must be taken to clean brushes and other tools immediately after use because dry acrylic is virtually impossible to remove from many surfaces, including clothing and floors.

Initially, acrylics seem difficult to control, but don't be dismayed by first attempts—work with them until you've mastered their use. They are a valuable and versatile medium, whatever the painting surface.

Acrylic Mediums

Acrylic retarder is a gel that retards the drying time of acrylic paint. It is usually available in tubes. Care must be taken to add the proper amount of retardant to the paint; follow the instructions on the container.

Acrylic flow release is added to acrylics in small amounts to reduce surface tension, thus increasing the flowability and permitting more even washes on paper or paperboard.

Acrylic gel medium is a thickening material that not only allows an impasto effect to be achieved but also makes the paint more transparent. It has very limited uses in bird painting.

2
Brushes

 Almost any hair, bristle, or fiber may be used in the manufacture of paint brushes, and all have different characteristics. The brush is painting's most important tool. There is nothing more frustrating or self-defeating than trying to work with a poor brush. Buy the highest quality brush(es) you can afford. Don't be dismayed at the array of shapes and sizes; only a few brushes are necessary for successful bird painting.

What determines a good brush is a combination of abilities: to carry an adequate load of paint, to hold a sharp edge in a flat brush, to hold a sharp point in a round brush, and to spring back into shape after use. Emphasis here will be on the materials and shapes used most frequently in bird painting with gouache and acrylic paints.

Types of Hair and Filament

Kolinsky Sable. The finest and most expensive brushes made are from Kolinsky sable, but even these will vary in quality depending on the manufacturer. Kolinskys are typically sold in the round shape and usually display all of the desirable qualities of a good brush. Although there are many brands, the two I recommend for availability and consistent quality are the Strathmore series 585 and the Winsor & Newton series 7.

Red sable. Sable hairs that are of a lesser quality than Kolinsky. Usually not as springy, and in rounds do not point up as well as Kolinskys. In other shapes—flats and filberts—they are fine brushes.

Sableline. A fancy name for dyed ox hair. They do not point up well in the rounds, but they have the ability to hold a good load of paint and are fine flat and large wash brushes.

Nylon. Sometimes described as synthetic sables, nylons have great spring but little ability to point or hold paint. The development of synthetic filaments has not yet reached the quality found in natural hair brushes.

Blends. The most common blend is nylon-sable, and although a better brush than pure nylon, it is still lacking in paint retention and the ability to hold a fine point.

Shapes of Brushes

Standard Round. Usually just called a "round," this is the most popular and versatile shape, found in a variety of sizes. Although this is called a *standard* round, various characteristics, such as hair length, may vary between manufacturers. The two most popular brands are Winsor & Newton and Strathmore. The brush I recommend in this style is the Strathmore Kolinsky Sable #585. It is an all-round good brush that holds a very fine point.

Designer Round. These have a longer thinner shape than do standard rounds and come to a narrow sharp point that can pull a very fine line. This is a good style but not quite as versatile as the standard round.

Flats. There are two categories to be considered in this style: watercolor and oil flats.

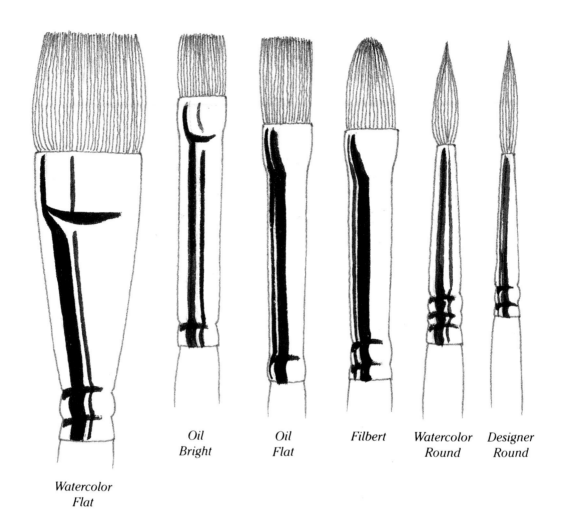

Oil
Bright

Oil
Flat

Filbert

Watercolor
Round

Designer
Round

Watercolor
Flat

Brush Shapes

Watercolor Flats. Initially, this brush category may seem confusing because watercolor flats may also be called *aquarelles,* which are large, thick flats, or one-stroke brushes that usually have slightly longer hairs than do normal flats. Regardless, they are all watercolor flats and all are used primarily for washes or filling in large areas. They are generally not available in very small sizes, and the most common sizes are 1/4, 3/8, 1/2, 3/4 and 1 inch. Red sable and sableline are the preferred hairs in this shape; lesser-quality brushes in this shape have a ragged edge, don't hold much paint and have the annoying habit of losing hairs when painting. Another brush to be considered here is a large flat called a *wash brush,* used, as the name implies, for putting washes on large flat surfaces. A good large wash brush is the 1 1/2- or 2-inch Oxhair by Strathmore.

Oil Flats. These come in a much greater variety of sizes, have shorter hairs, and are more stout than watercolor flats. Oil flats are used for oils and acrylics on canvas or wood. The *bright* is another flat but with slightly shorter hairs than the oil flat.

14

12

10

8

7

6

5

4

3

2

1

0

00

000

Watercolor Rounds (Actual Size)

Filbert. This is a flat but with a rounded rather than a square tip. Traditionally regarded as an oil-painting brush, it is now an important shape for painting birds in both gouache and acrylic. Used in an unconventional manner it produces unique featherlike marks (see Techniques). The various sizes of this brush make different sizes of feather marks, so the size you will need will be determined by the size of the bird being painted. The various types of hair used in this style make different types of marks. Red sable would be the best hair choice with which to start, but be sure to experiment with other types of hair and bristle.

Care of Brushes

Several good brushes may represent a considerable investment, so it is wise to care for this investment with the small amount of time it takes to keep brushes in good condition. Cleaning water-based paints from brushes only requires thorough rinsing in body-temperature water, then gently scrubbing them with a pure soap, such as Ivory bar soap. After rinsing all the soap out, reshape the tip of the brush and hang it hair- or bristle-down to dry. When you are using several brushes it is difficult to stop painting and clean them. In such cases, you can use a brush washer or brush holder: a container of water with a coiled metal holder mounted above the water level. When the brush handle is put in the coil, the hairs are suspended in the water, keeping the paint in the brush moist until it can be thoroughly washed.

If you have extra brushes or some that are used infrequently, store them in a closed—but not airtight—container along with some moth crystals. (Moth larvae love to munch on hairs and bristles.) With proper care some brushes may last a lifetime, but even if the ends wear off they are still useful (see Techniques).

Buying Brushes

The ideal way to buy a brush is to go to an art-supply store where you can test the brush before buying; it is especially wise to test the quality of sable rounds. To test, wet the brush in water to remove the starch (used to protect the brushes), then, when it is thoroughly wet, flick the brush quickly to see if it points well. After that, press the damp hairs sideways on a hard surface, then release them to see if the brush snaps back into shape. If the brush behaves well, buy it; if not, repeat the performance with another brush. It is often necessary to order brushes from a mail-order company. Stick with reliable brands and you will usually be pleased. If not, most firms have a complete return policy.

The recommendations given here are intended only as a guide. All artists have individual preferences; the best way to satisfy your artistic needs is to experiment until you find the brushes that are best for you.

3
Painting
Surfaces

 Although any surface may be painted, only those widely used with gouache and acrylic will be covered here. **Watercolor papers** are available in a wide variety of weights, finishes, and shades of white and gray. The following is an overview of the terms used to describe watercolor papers and their characteristics.

Watercolor paper is commonly available in three finishes or surface textures, although the degrees of texture on same-named finishes can vary from one manufacturer to another. These papers are available in rolls, pads, and individual sheets. Although watercolor paper is intended for use with transparent watercolors, gouache may be used on it with great success; however, it is not recommended for the inexperienced acrylic painter.

Hot press is the smoothest surface and will take very fine-line detail. It is used mainly for hard-edged paintings. The surface has very little "tooth" (roughness to the fiber) to hold paint, which has a tendency to lift off the paper at inopportune times.

Cold press is the intermediate finish between hot press and rough. With a moderate surface and tooth, it is the finish of choice for the beginning artist.

Rough, as the name implies, is a very rough finish, and because of this is a very difficult surface on which to work. It is an attractive surface but does not lend itself to detailed paintings.

Watercolor paper is listed by weight as well as finish and, if the paper dimensions are the same, the higher weight will be the thicker paper. Size is

Watercolor paper surfaces. From the left: *rough, cold press, hot press*

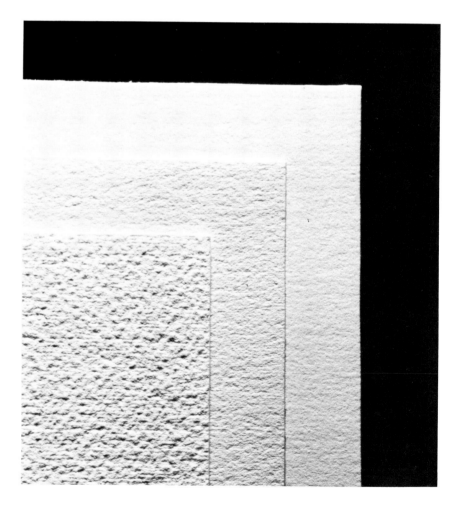

important because the standard is based on how much a ream (500 sheets) weighs, no matter the size. Thus, a larger sheet of the same thickness will be listed at a greater weight.

Most lighter-weight watercolor papers must be stretched prior to use to avoid buckling. This is a simple process. Soak the paper in a pan or tub of water, remove the paper when thoroughly wet, and drain off excess surface water. Then place the wet paper on a flat surface, such as a drawing board, and tape all around the edges using a gummed paper tape. Tack the corners through the tape and let dry. The paper will dry very tight and may be used taped to the board or cut free. Stretching is not necessary with heavy-weight watercolor papers.

Illustration and watercolor boards are stiff boards with either illustration or watercolor paper adhered to one side. Because of their stiffness, these boards can stand rougher treatment than papers and do not require any prepainting preparation.

Illustration board is lighter in weight than watercolor board and has a slight tendency to warp when large areas are painted. To remedy this problem, brush a thin coat of gesso or paint on the reverse side to equalize the pull of the paint, thus flattening the board. Illustration boards are available in two surfaces: *hot press* and *cold press*. Hot press is the smoother and less desirable of the two. Cold press provides good surface for both gouache and acrylic.

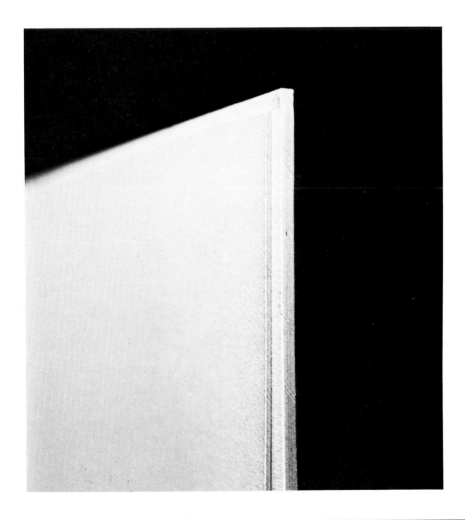

The difference in thickness between illustration board (left) *and watercolor board* (right).

Watercolor boards are made with a heavier backing than are illustration boards and thus are more resistant to warping. Because the surface is watercolor paper, it responds well to paint. The three surface finishes available are the same as those described for watercolor paper. The watercolor board I prefer is Crescent #112 cold press, a very heavy board with Strathmore watercolor paper adhered to it. Gouache and acrylics may be used with great success on this fine board.

Matboards are made of tinted papers adhered to stiff backing. There is a temptation to use this board for painting and it can be done; just be aware that the tinted paper will fade badly.

Hardboard, commonly known under the trade name Masonite, is made of compressed wood fibers and is found in tempered and untempered forms. Only the untempered board should be used for painting because the tempered board is impregnated with oil. Before painting, the board must be coated with acrylic gesso to provide a suitable ground (surface) for the paint. Preparation with gesso requires rolling or brushing a base coat of thinned gesso, then sanding with fine sandpaper, dusting, and applying more gesso. Repeat this process until at least three coats of gesso are on the surface. The reverse side of the board also must be coated, but it need not be sanded. This offsets the board's tendency to bow by creating surface tension on the reverse side. Gouache may be used on hardboard panels but only with limited success. Acrylics work well on hardboard, but exercise patience because paints initially go on the slick gesso surface rather irregularly. After additional applications of color, however, the paint goes on smoothly. A finished acrylic painting on hardboard is very crisp and bright.

Primed linen canvas

Canvas is available in both linen and cotton and both are sold in different grades and weaves: the tighter weaves are the more expensive. Gouache may be used on canvas, but acrylics are used with much greater success. Because of the inherent texture of the fabric, canvas does not easily lend itself to fine-line paintings—except for portrait linen canvases.

Cotton canvas is available in several forms: rolls, panels, pads, and prestretched; the form most suitable for acrylics is the prestretched, acrylic-primed canvas. Found in a wide assortment of sizes, these canvases are ready to use and easy to store. The surface of cotton canvas can be rather coarse, with irregularities in the weave.

Linen canvas is more tightly woven, stronger, smoother, and more expensive than cotton canvas and is available only in rolls or prestretched and primed. The latter is preferable for our purposes. Because of the weave and stability, linen canvas is the choice of many artists because its fine surface permits detailed paintings.

Wood has also been traditionally used as a painting surface. Especially relevant here is the carved wood used by bird carvers. Finished carvings must be primed to accept the paint and to provide a white ground that enables the colors to be crisp and clear. Wood must first be sealed with clear lacquer or sanding sealer, then one or two coats of acrylic gesso, thinned to the point where it will not fill in carved detail, is brushed onto the surface. When dry, this provides an excellent ground for acrylics. Gouache is not suitable for carvings because of its soft surface.

Primed cotton canvas

Additional Mediums, Tools, and Accessories

Just a peek inside an art-supply store or catalog is enough to bewilder any artist. Besides the array of brushes, paints, and paper, there are myriad accessories and gadgets, some useful, some not. Listed here are only those additional art items that are necessary for successful bird painting.

Liquid masking fluid (liquid frisket) is a thin rubber-cementlike fluid that is painted over an area to be left white after painting washes or specific areas. Use a worn or inexpensive brush to apply the frisket because it quickly dries and balls up in the brush. Immediately after use, wash the brush in water. When the background color is completely dry, remove the frisket by gently rubbing it off with your finger(s) or with the help of a rubber cement pickup. Liquid frisket is used extensively in bird painting (see Techniques).

Palettes may be made of metal, plastic, paper, china, wood, or glass. Available in any shape or size, some have wells to hold the color, and some have lids to keep the paint moist. Despite the variety available, the best palette is usually the simplest one and almost anything that will hold paint can be used. Most acrylic painters prefer something that is peelable or disposable, such as an old plate, pizza pan, or hardboard scrap. A pan with a shallow lip or an enameled tray is ideal for gouache.

Transfer paper is a thin paper coated on one side with graphite, and it is used to transfer a drawing to another surface. Available commercially, you also can easily make it by rubbing a thin coat of graphite from a soft pencil or graphite stick on one side of a piece of tracing paper or on the reverse side of a drawing, then smearing the graphite around with a tissue to get a more even coating. To transfer a finished drawing to the painting surface, prepare the back of the drawing as described or place a piece of transfer paper between the drawing and surface, trace over the lines of the drawing, remove the drawing, and the traced lines are transferred to the painting surface. This acts the same as carbon paper, which, incidentally, should not be used for drawing transfers because carbon paper smears badly and is difficult to erase. If the transfer is to be made onto a dark surface that will not show graphite, instead smear the back of the drawing with silver- or white-colored pencil, and white lines will be transferred.

Brush washers or *Holders*, as mentioned previously, are a handy and inexpensive piece of equipment.

Water jars hold water used for diluting paints and washing brushes while painting. From hand-thrown pots to a canning jar, you can use anything that will hold water.

Spray bottles are used to evenly prewet surfaces. Trigger types are superior to pump types; they may be purchased empty at nurseries, hardware stores, and beauty shops.

Sponges, both natural and artificial, have a variety of surface textures and are used for special effects as well as controlling water and washes.

Hobby knives (X-acto types) are used in painting to scratch white lines on painted surfaces and to carefully remove unwanted hairs, paint flakes, and so on, that may suddenly appear on a painting.

Tissues, paper towels, and *rags* are always handy for removing excess paint or water and for blotting paint from brushes.

Q-tips are a ready-made tool for blotting small areas of paint, as in lifting off (see Techniques).

4
Techniques

All the basic techniques discussed here apply to gouache. Not all, however, apply to acrylics because they cannot be re-worked when dry; alternate techniques are described for them. Though every effort is made to indicate how the techniques are executed, it is difficult, if not impossible, to describe the proper consistency of a paint, the wetness of a wash, or the amount of pressure on a brush. These are variables that can be learned only through doing. Even experienced artists keep a board scrap handy while painting to continually check for consistency, color, load of paint in the brush, or to practice line shapes. Don't be discouraged—these techniques are easy to master through practice.

Flat Opaque Colors. Dilute the paint to a creamy consistency and, using the appropriate brush size for the area being filled, use broad strokes to fill in with opaque color. Acrylics may require two coats to cover completely.

Wet-in-Wet Wash. This technique is used for backgrounds or on the bird itself wherever a continuous, even, transparent color is desired. For a large background wash have a puddle of thinned paint ready to go, then place the board on a slight angle so that the water, and then the paint, will flow slowly and evenly down the board. Thoroughly wet the board surface so it shines; then, starting at the top of the board and working downward, brush on the thinned paint from side to side, adding paint and brushing until an even wash is obtained. If the first wash is too thin, wait until completely dry and repeat the process. When working a small area on a bird, wet only the area to be colored and brush carefully. The paint will brush evenly into the premoistened area, giving a beautiful, thin, even coat.

Graded Wet Wash. The preparation is the same as that for a wet-in-wet wash, the difference is that the brush is charged with paint only once and, as the brush works down the board, there is a decreasing amount of pigment so that the final effect is a graded tone. After the first color to be graded is applied, it is often washed down the surface with a clean damp brush. This is very useful in bird painting, especially for achieving a shaded effect in acrylics by grading a wash over a base color (glazing).

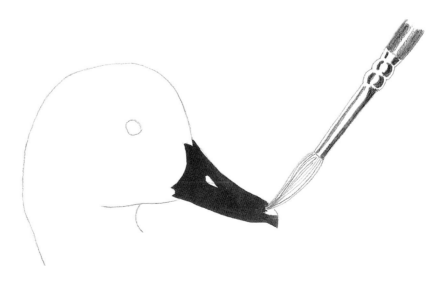

flat opaque colors

wet-in-wet wash

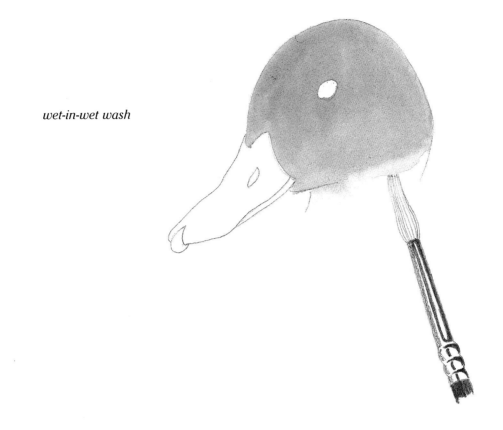

graded wet wash

Wet Blending. Paint two areas of color close to each other on a damp surface and work the edges of each color into the other while still wet until a blended effect is achieved. This technique may be used with acrylics, but you must plan ahead and work the colors quickly toward each other and blend them while still wet. To soften the edges of highlights, such as on bills, claws, or with splitbrushing, the softening must be done while the highlights or splitbrushing is still wet. Each color stroke must be blended (softened) with a clean damp brush as the color is applied.

Dry Blending. This technique is easily done with gouache, but impossible with acrylics. This is, quite simply, blending two adjacent dry colors with a clean, damp brush. Use a light touch on the brush and move it back and forth across the colors' edges until they are coarsely blended, then brush along the edge to achieve a smooth blend. This is very handy for softening the edges of thin lines, as on wing edges, and for highlighting on claws and bills.

Glazing. This is an application of a thin wash of color over an already dry one, allowing the colors to mix visually. A graded wash painted over a base color is an example of glazing. Acrylics lend themselves beautifully to this technique, but care must be taken with gouache not to overwork the second color on the surface or the colors will bleed together.

Drybrush. Although this technique is rarely used on the image of the bird, it is frequently used on the supports (twigs, logs, and so on). The brush is charged with color, blotted until almost dry, then dragged across the surface creating an unpredictable broken, shaded effect. The tip or side of the brush may be used.

Splitbrush. Also known as *heeling* or *feathering,* this technique is versatile and fun—and one that may be overused. A round brush is charged with paint and severely pinched or pressed down at the heel (where the hairs and ferrule meet) until the hairs spread apart. Then the tips of the spread hairs are brushed lightly across the surface to make a series of tiny lines. The brush may be blotted to produce drybrush broken lines. A graded or blended effect may be achieved by using a series of light, short strokes on the edge of a color. Short, light splitbrush strokes are a very effective way to soften the

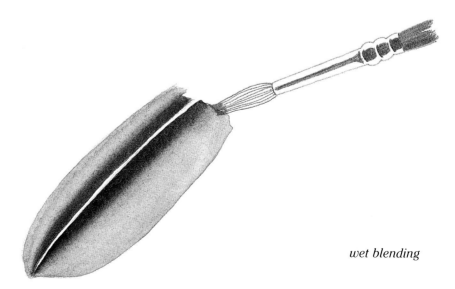

wet blending

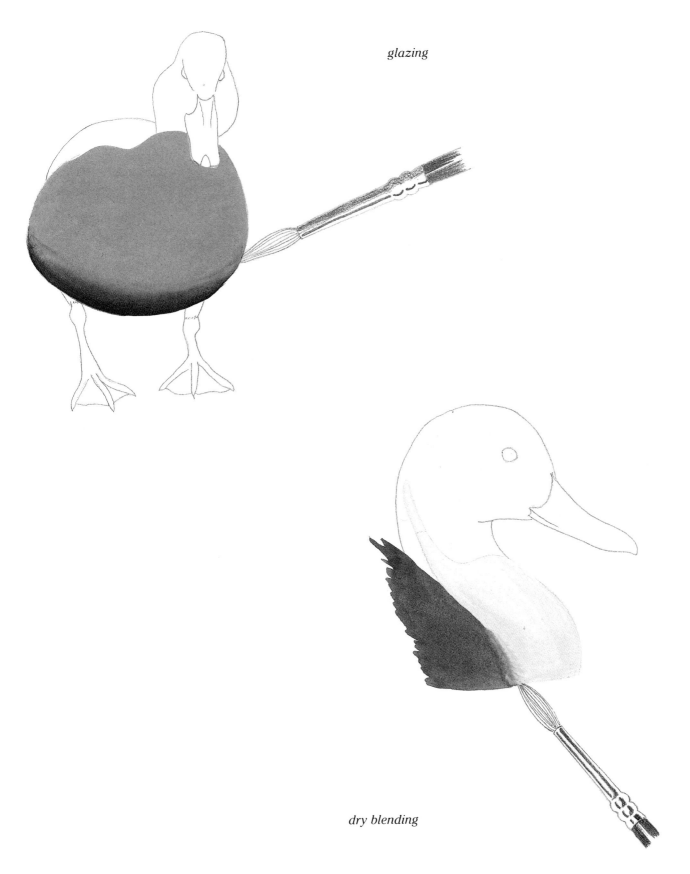

glazing

dry blending

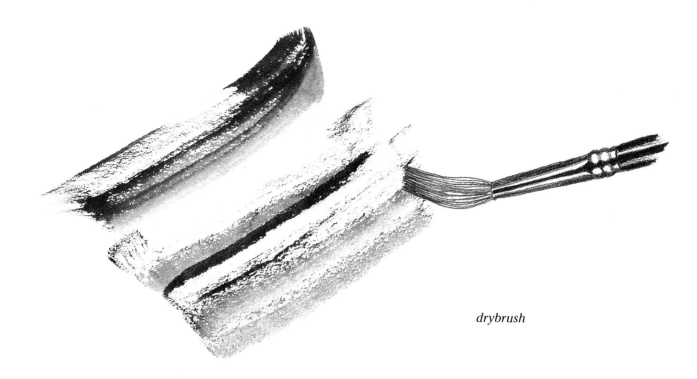

drybrush

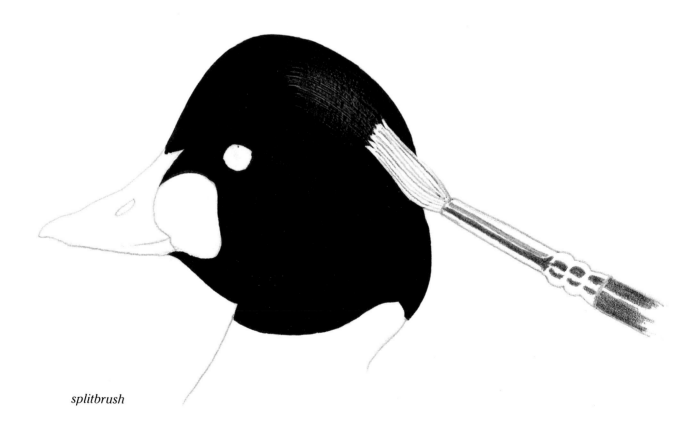

splitbrush

edge of wet acrylic paint, producing a blended effect. This is very hard on brushes; old, worn brushes are recommended.

Tipping. The filbert-shaped brush is most effective for tipping, and care should be taken not to overuse this technique. The brush is not held in the conventional manner, like a pencil, but instead is held almost parallel to the surface at a slight angle. The brush is charged with paint, then the tip is lightly pressed and lifted from the surface. Varying amounts of paint, degree of pressure, or pressing then pulling the brush, produce a wide variety of featherlike marks.

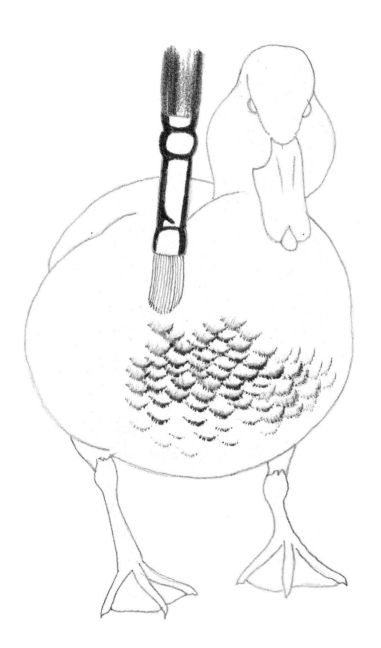

tipping

Lifting Off. Rather than adding color to the surface, this subtracts color (it cannot be done with dry acrylics). A brush filled with clean water is lightly scrubbed over a selected area of dry paint. While the area is still wet, a Q-tip or clean, dry brush is used to lift the loosened pigment from the scrubbed area. This leaves a subtle highlighted area, the shape and size of which is determined by the motion of the wetted brush.

Detailing. Usually the last technique used on a painting, this adds the finishing detail. It is usually executed with a small, fine-point round brush. In bird painting, the wing edges, highlights, and other finishing touches are described as detailing.

Spatter. This technique is not used on the bird but rather on the background to suggest an irregular sandylike surface. It is accomplished by dipping an old toothbrush in very thin color then lightly rubbing the bristles of the toothbrush with a stick or finger. As the bristles snap back and forth, random-sized dots of color appear on the surface. Both light and dark colors may be spattered. To control the area being spattered, frame it with pieces of torn paper; this will give a varied and more interesting edge to the spattered area.

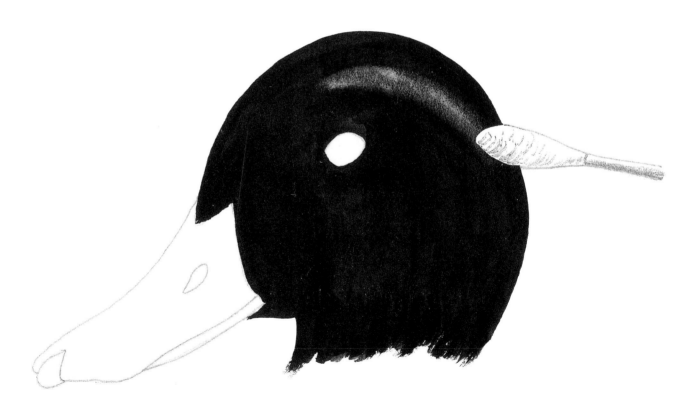

lifting off

detailing

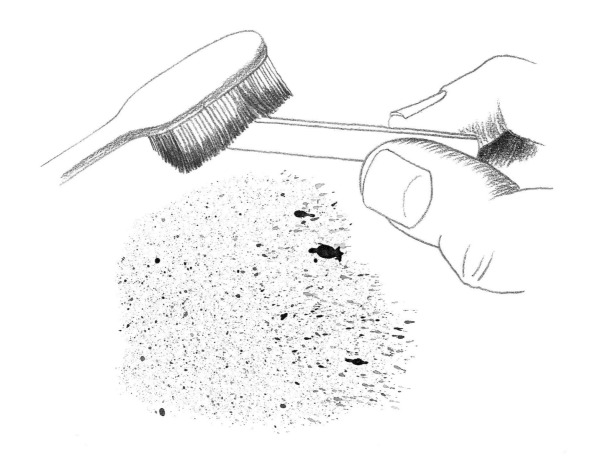

spatter

5
Putting the
Techniques Together

 You have read descriptions of the various techniques used to paint birds, now it is time to see how they are applied. Naturally, the complexity of the bird being painted will determine how many techniques are used in the painting. The lesser scaup example employs a wide variety of these techniques, including tipping, splitbrush, wet-in-wet wash, and glazing. It also demonstrates the use of transferring and liquid masking. The painting was done on cold press watercolor board with #1 and #3 Kolinsky rounds and a #4 filbert, except for the background wash where a 1½-inch sableline brush was used. The #3 round is the brush used except where otherwise noted.

The drawing is prepared for transfer by rubbing the back of the paper with graphite.

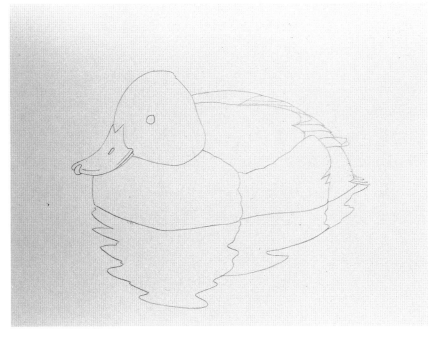

The drawing is transferred to the painting surface in the manner described on page 22.

The bottom of the duck is coated with liquid masking so that the wash will not color the bird (refer to page 22). When the masking is dry, a thin wet-in-wet wash is painted to show water. Working quickly, while the wash is still wet, opaque lights and darks are stroked into the wash to produce highlights and shadows on the water.

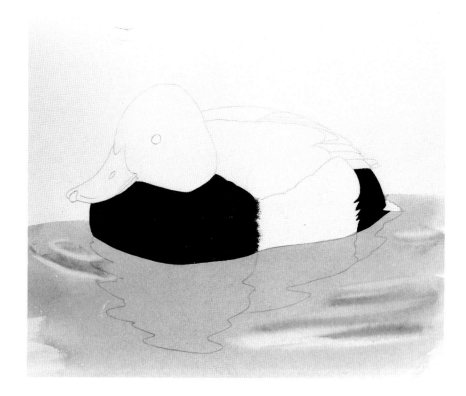

The masking is removed. A thin wet-in-wet wash of white is painted on the flanks and scapulars. When these washes are dry, a dark opaque color is applied on the breast and the upper-tail and undertail coverts. Where the dark of the breast meets the light of the flank, a splitbrush is used to show an irregular edge.

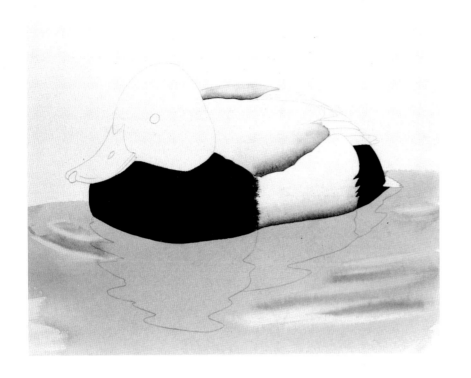

In this step, a series of glazed and graded washes is executed to show shading and form. Turning the picture upside down and starting where the shading is to be darkest, a line of dark color is painted. The dark color is then glazed and graded over the light areas with a clean damp brush.

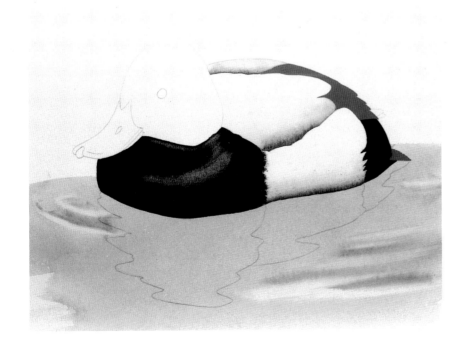

Lifting off will show a subtle highlight on the breast. A wet Q-tip is rubbed on the dark breast to loosen the paint, which is then blotted off with a tissue. This may be done with acrylics, but the lifting off must be done while the dark breast is still wet. Opaque color is painted on the tertials and tail.

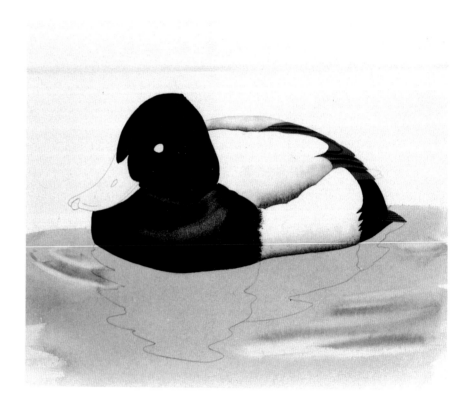

A thin shadow line is painted under each tertial and tail feather. As each line is painted, the brush is cleaned and the shadow line is glazed and graded down over each feather. The head is painted with opaque color.

It is decided to now paint the reflection. (It could be put in at any time.) The reflection is a duplication of the duck's basic colors, and it is done in a series of thin wet-in-wet washes.

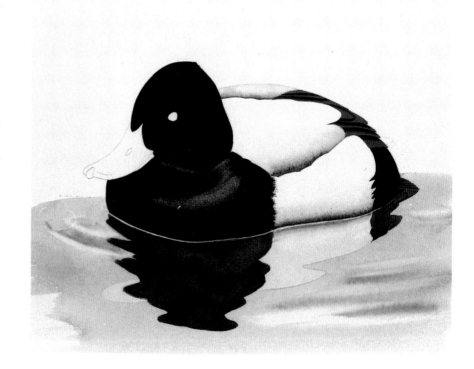

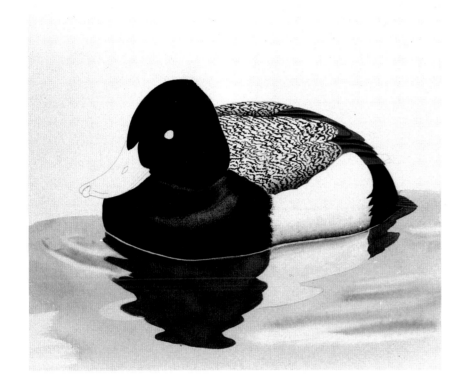

Dark color painted with the #1 round applies details in the bold vermiculation on the scapulars.

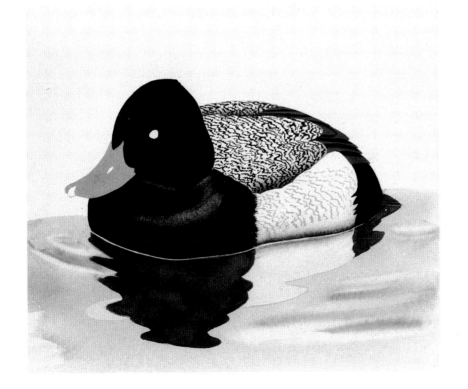

Lighter, less distinct vermiculation is detailed on the sidepocket. The base color of the bill is painted in with opaque color.

Alternating between light and dark colors where appropriate, the #4 filbert is used to tip in the breast feather edges. Highlighted areas on the head are painted with a light color by the splitbrush.

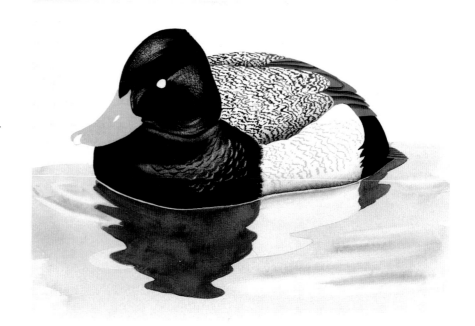

The tips of the primaries are painted in with dark opaque color; the iris of the eye is detailed with light opaque color. The dark nail and nostril on the bill are painted in opaquely, as are the rough white highlights and shadows.

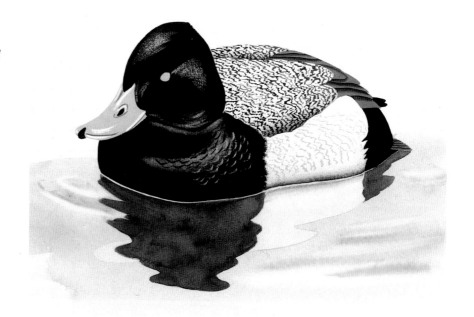

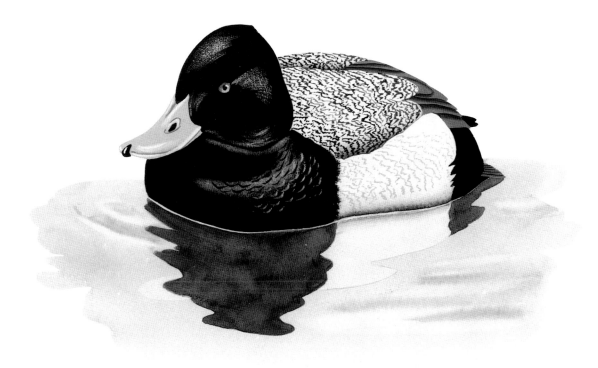

The highlights on the bill are softened with a clean damp brush. With acrylics this must be done while the highlights are still wet. Opaque color is used to detail the pupil of the eye; a light shadow is painted at the top of the eye and blended down into the iris. To complete the lesser scaup an opaque highlight is painted in the eye.

6
Describing
Diving Ducks

Body Feathers

Diving ducks spend much of their time feeding underwater, therefore it is essential that their feathers remain dry, so they may again rise to the surface and immediately take flight if necessary. This is accomplished in two ways: the construction and arrangement of the feathers allows air to be trapped and held, which acts as an effective water repellent; and diving ducks have a large oil gland that is used when preening to coat the feathers with a light covering of water-resistant oil. The wing feathers are most vulnerable to becoming wet; but they are protected by the sidepocket (flank), which covers most of the wing and is oiled especially well during preening.

The names of feather groups on ducks correspond to those of other birds. In the case of ducks, however, two groups have been given other names: the flank feathers are known as the sidepocket, and the secondaries of the wing are called the speculum. These two names will be used interchangeably throughout this book. It is important, I'd even say essential, to become familiar with the terms used to describe the feather groups. This not only will aid identification but also will facilitate following the painting examples.

Painting and understanding duck feathers poses distinct problems not usually found in other bird groups. These are iridescence, vermiculation, and seasonal plumage changes. To the beginner these problems may seem great, but they are not. The following descriptions should help take the mystery out of understanding and dealing with them.

Iridescence. Iridescence is the characteristic of feathers to reflect brilliant colors. The structure of the feathers interferes with light rays that strike them, making the light break up and scatter, giving a changeable brilliant effect as opposed to a solid field of color. Although changeable in intensity, the color and shade usually depend on the angle and quality of light (bright or dim) striking the feathers. On overcast days or in shadows, feathers that would normally iridesce a great deal appear to be a dull gray.

The basic way to paint iridescence is to have the main color, for example a dark green, blend into black for contrast, and then paint lighter shades of green on top of the dark green until an iridescent effect is achieved.

Certain pearlescent paints have qualities that enable them to scatter light much like iridescence. Although selected use of these paints is very effective in wood carvings, their use on flat surfaces produces a glitzy, hard look that detracts from the painting.

Vermiculation. Vermiculation literally means wormlike marks. On ducks these are the dark wiggly patterns usually on the sidepocket and/or scapulars. At first glance, the vermiculation appears to be a continuous pattern; a closer look, however, reveals that this is not the case. Each individual feather, whether on the sidepocket or scapular, has a separate pattern; the human eye sees the overlapping of the feathers and tries to make it into a continuous pattern. In reality, the feathers create a random pattern that almost never duplicates itself. The tiny gray or gray-brown lines, which comprise the pattern, may range from spotty and light to bold and dark depending on the species. The wetness or dryness of the feathers also may affect how dark or continuous the patterns appear.

Painting vermiculation takes observation, time, and patience—it is tedious work. When painting a very detailed close-up duck picture, each feather vermiculation should be detailed with either a small, round brush or with a

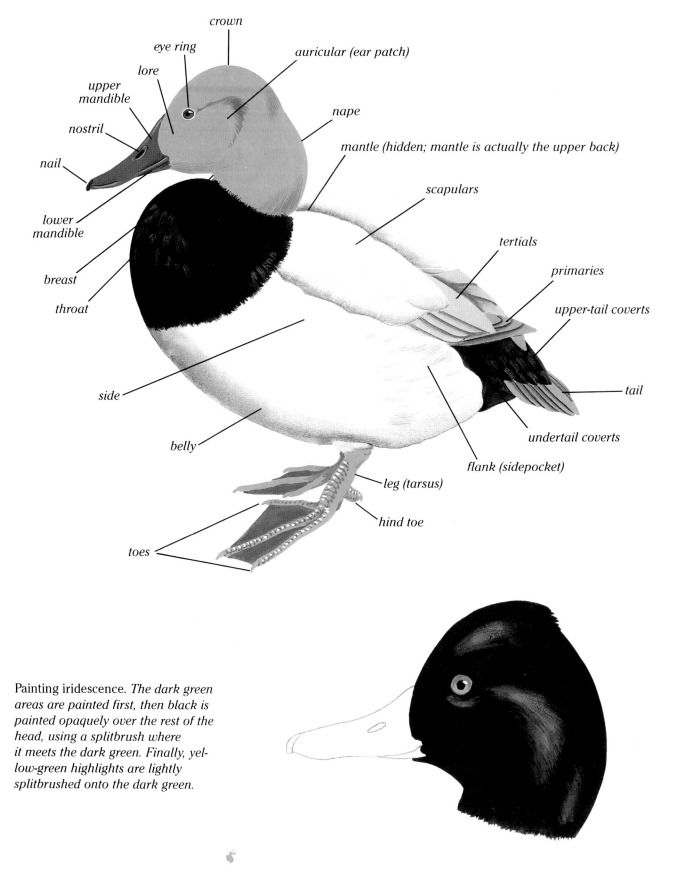

crown

eye ring

auricular (ear patch)

lore

upper
mandible

nape

nostril

mantle (hidden; mantle is actually the upper back)

nail

scapulars

tertials

primaries

lower
mandible

upper-tail coverts

breast

throat

tail

side

belly

flank (sidepocket)

undertail coverts

leg (tarsus)

hind toe

toes

Painting iridescence. *The dark green areas are painted first, then black is painted opaquely over the rest of the head, using a splitbrush where it meets the dark green. Finally, yellow-green highlights are lightly splitbrushed onto the dark green.*

small-tipped drafting pen loaded with thinned paint. When painting a picture where the duck is at a distance or need not be as detailed (such as the painting examples in this book), the vermiculation need not be as precise; groups, rather than individual feathers, may be painted. Unfortunately, even when painting general vermiculation, there are no short cuts; each line or dot must be painted separately.

Plumage Changes. All birds go through a period of seasonal plumage change (molting), when the old feathers must be replaced with new. What makes a duck's molt so distinctive, however, is that the change is much more apparent and occurs at certain times of the year for specific species. When painting backgrounds and vegetation, you must be sure that the color and condition of the habitat matches the duck's seasonal plumage.

Vermiculation

Body Shape

The body shape of diving ducks is determined by their response to the conditions around them and to the wetness or dryness of their feathers.

It is relatively easy to judge whether a duck is excited, calm, or watchful. Body shapes and attitudes are exaggerated in response to external stimuli. A relaxed, calm, resting duck has its head tucked into its body, the body feathers are relaxed and loose, the scapulars droop; it has a rather plump look. When wary and watchful, the neck begins to extend and the feathers start to compress. When alert and greatly excited, the neck is fully extended, the feathers are compressed to the body, and, if floating, the duck rides lower in the water. The appearance is of a longer, sleeker duck.

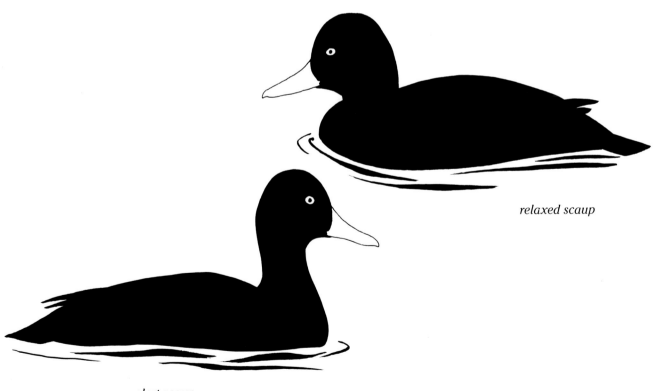

relaxed scaup

alert scaup

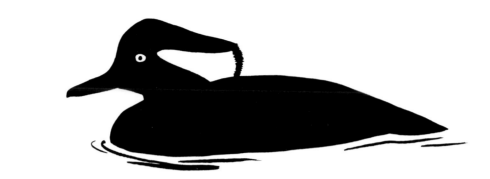

relaxed hooded merganser

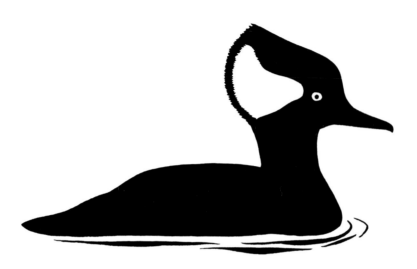

alert hooded merganser

There are exceptions to these rules, however. An excited hooded merganser erects its head crest and displays the large white patch rather than folding it tight to its head.

The wetness or dryness of the feathers will also affect the body shape. When dry, divers have a more full-bodied look. When wet, after feeding, the head and neck feathers are slicked back and provide a very slim profile. Though most of the body feathers will look the same, the sidepocket may be very damp and appear to be compressed, unlike the smooth appearance it has when dry. This dampness is especially evident in diving ducks because they are submerged much of the time.

Wings

The wings of diving ducks are relatively small in relation to their body size and more pointed than those of dabbling ducks. This makes them well suited to swift, sustained flight, but the lack of surface area prohibits them from rapid maneuvering or vertical takeoffs from a resting position. Most divers must run across the water surface and flap their wings until they gain enough momentum to become airborne. The diver's feather groups on the outer part of the wing are quite easy to identify, but the feather groups on the

Parts of a Hooded Merganser Wing

Upper Wing

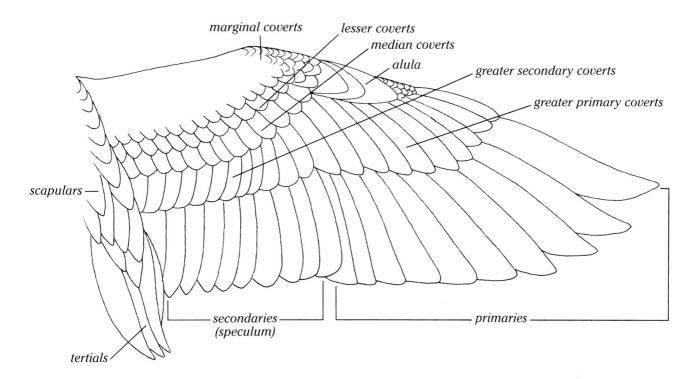

marginal coverts
lesser coverts
median coverts
alula
greater secondary coverts
greater primary coverts
scapulars
secondaries
(speculum)
primaries
tertials

Underwing

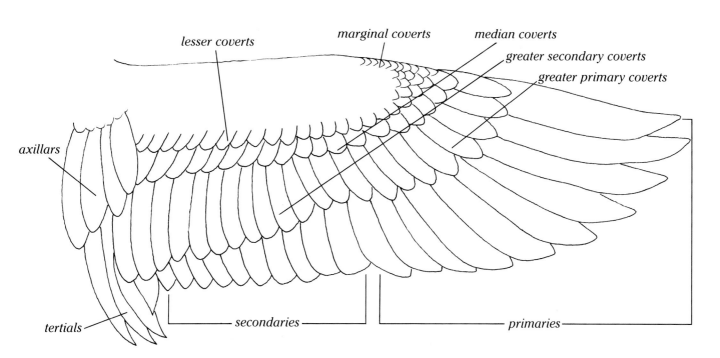

lesser coverts
marginal coverts
median coverts
greater secondary coverts
greater primary coverts
axillars
tertials
secondaries
primaries

inner part of the wing, the scapulars and tertials, often blend together and are more difficult to separate.

For painting accuracy, it is necessary to know how the wing feathers overlap. It is also essential to know the correct number of larger (flight) feathers in the wing: there are always ten primaries and ten secondaries (the speculum). Notice how the size and profiles of the tips of these feathers vary. Most of the North American divers have no iridescence on the speculum. There are usually five tertials, but this varies between species. The tertials are actually part of the secondary feather group, but because of the difference in size and shape they are given a name of their own. The tertials show variation in shape and size not only between species but also between males and females of the same species. To add to the variables, it is often difficult to delineate where the tertials end and the scapulars begin; many of the hindmost scapular feathers have the same shape and coloration as the tertials. There is a saving factor in all this confusion; because the groups may be visually inseparable, it is usually not necessary, or practical, to separate the two groups, in the painting. Realize, however, that there are two distinct feather groups; the groups may be indistinct in most species of divers but in the old-squaws, eiders, and mergansers the tertials are large and quite spectacular.

As mentioned previously, the folded wing of a resting duck tucks neatly into the sidepocket feathers on the bottom and is covered on the top by the scapulars and tertials. This protects the wing from weather extremes. On a resting bird the only parts of the wing usually visible are the tips on the outermost primaries and a small part of the speculum. Although the main part of the wing is hidden on a resting duck, the wing feather groups and their relationship to one another are fully visible when the bird is in flight (see the greater scaup painting in chapter 7).

Tails

The tails of diving ducks are easy to describe: short, stiff, and plain. Naturally there are exceptions: the old-squaw, which has a long pointed tail, and the ruddy duck, which has a rather short tail that it holds erect and fanned. When swimming, most divers carry their tail parallel to the water or depressed with the tips of the tail feathers in the water.

The number of tail feathers varies between species; the feathers are all visible, however, only when the tail is fanned out. When the tail is folded only

A partially folded wing. The feathers will overlap more when the wing is completely folded and tucked into the body.

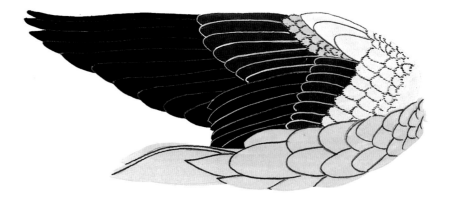

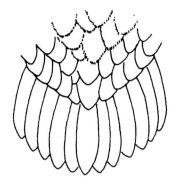

Tail of a diving duck. The upper-tail coverts that cover the oil gland are shown with broken edges. Note that the undertail coverts extend almost to the tip of the tail.

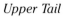

Upper Tail *Undertail*

a small portion of the feathers' edges show; this may conceal a pattern that is on the central portion of the tail feathers. When painting a fanned tail you need good reference material to check if there is a hidden pattern or not.

The innermost upper-tail coverts are large feathers that cover the large oil gland used in preening. The feather shaft on the tail feathers changes placement as the feathers progress from the outside of the tail toward the center. On the outer feathers it is closer to the outer edge, but moves toward the center of the feathers as they go inward. The exception to this rule is the upper-tail coverts immediately adjacent to the tail.

The undertail coverts tend to blend together with no distinct margins. These feathers are actually quite large and, in most cases, extend almost to the tips of the center-tail feathers.

Bills

The bill is one of a duck's most distinctive features. Although it is common to all ducks, its shape, size, color, and angle to the head varies between species. The diversity of bills is especially apparent in diving ducks. The canvasback and redhead, for example, boast similar coloration and body shape but the profile of the head, the angle of the bill in relation to the head, and the size of the bill are very distinctive characteristics.

There are several features that are common to most duck bills. Bills have an upper and lower mandible, and, typical of all birds, only the lower mandible moves, with the upper fused to the skull. The two bill parts are attached by skin, and this becomes obvious when the bill is opened wide. When closed, the lower mandible tucks under the upper except at the edge closest to the head. Lamallae are also on both mandibles. These are tiny projections that act as strainers, letting water out of the bill while retaining the food. The bills of most divers are typically flat with no ornamentation; the scoters, however, have a fleshy protuberance at the base of the bill and mergansers' bills are long and slender with toothlike serrations used for capturing and holding fish.

On the end of the bill is the nail. It is especially apparent on the upper mandible. Again, the shape and size of the nail varies between species. The nostrils of diving ducks are almost parallel to one another and have a slight ridge running above and beneath them. In addition, they are located toward the center of the bill rather than close to the head.

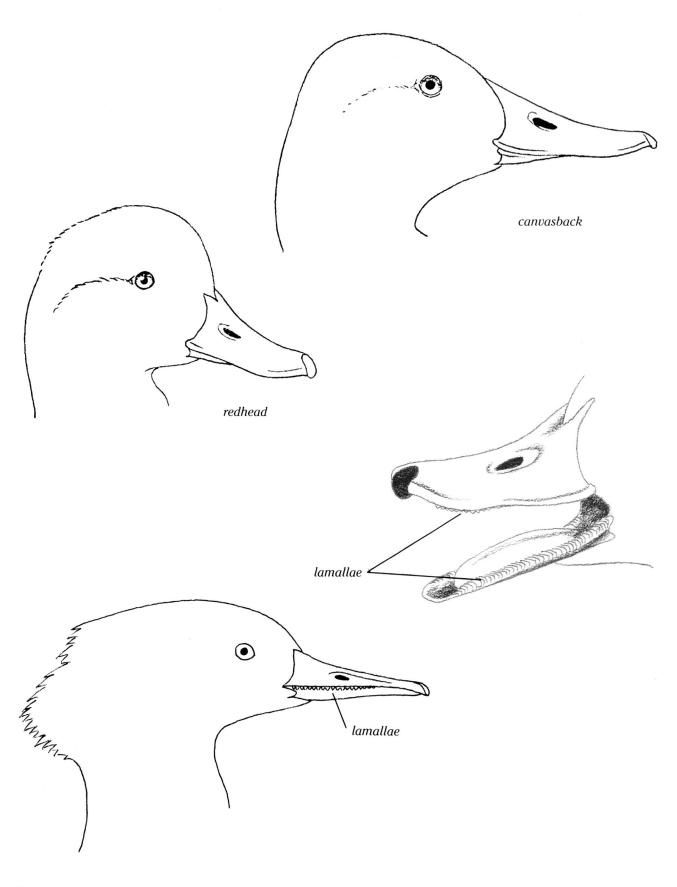

canvasback

redhead

lamallae

lamallae

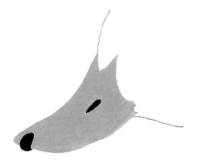

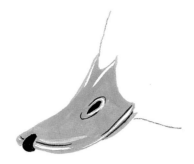

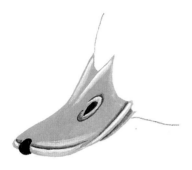

Painting the bill. *The nostril, nail, and main bill are painted with opaque color. Rough opaque highlights and shadows are added. The highlights and shadows are softened, by blending the edges, and refined. More color is added to each if needed.*

Bill colors range from the dark, plain bills of the goldeneyes to the brightly colored bills of the eiders and mergansers. The color is contained in a thin membrane that covers the hard, bony bill, and the color quickly fades in death. Some bills have patterns and, although the pattern for a given species is fairly consistent, slight differences do occur. Seasonal plumage changes also affect the bill color.

Feet

Webbed feet are another distinctive feature of ducks. Folding forward on the upstroke and fanning out on the backstroke, the feet are beautifully designed for propelling ducks through the water. Large feet are especially important to diving ducks because they are the primary means of propelling them down toward their food. Some divers also use their wings in the descent, but most have the wings tucked tightly in the sidepocket and only the feet are used. The legs are located more toward the body's sides and rear then those of dabblers; this anatomical structure gives greater thrust and power then diving. Although efficient for diving, the legs and feet are not adapted for walking gracefully on land. Because their feet are so large, divers have a tendency to place one foot on top of the other, thus making walking awkward. In addition, because of the rearward position of their legs, the divers must stand more upright than do dabblers to maintain their balance.

The foot has four toes: three forward toes and one large hind toe. The

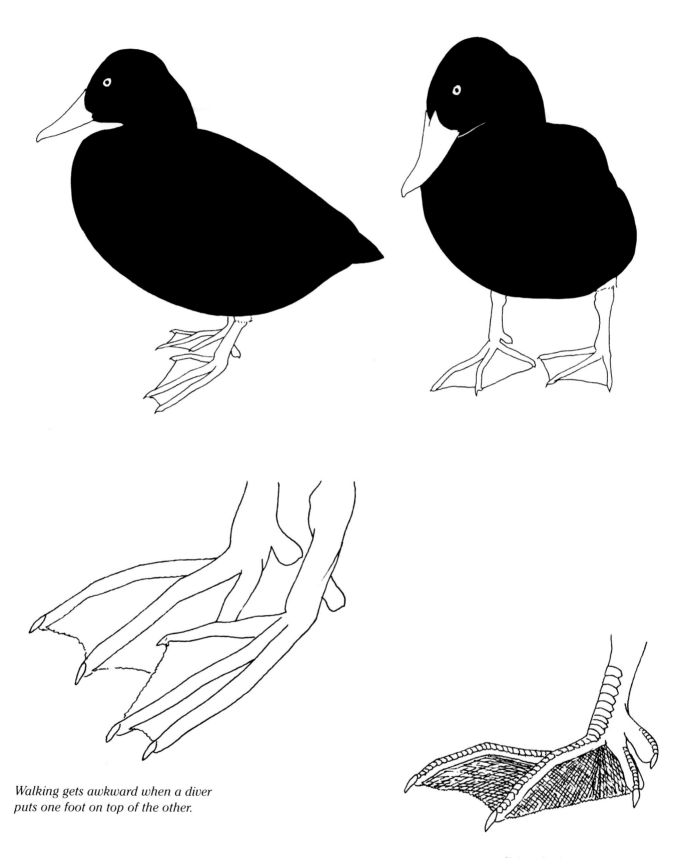

Walking gets awkward when a diver puts one foot on top of the other.

diving duck foot

forward toes are slightly curved and each has a different number of joints. The outside toe has three joints, the center toe has two, and the inside toe only one. The inside toe also has a small flap of skin on its outside edge. The large hind toe angles toward the inside of the foot and also has a large flap of skin. The web of the foot is flexible and, when on land or logs, will conform to the surface on which the duck is standing. The surface of the web has a reticulated pattern. The colors of legs and feet range from solid bright colors to drab shades.

Eyes

Although the eyes of ducks are placed on the side of the head, they are set in a deep indentation that is not found in other birds. This indentation runs from the bill past the eye and toward the back of the head where it disappears; undoubtedly it allows for better vision around the bill. When looking straight ahead ducks have binocular (two-eye) vision; when looking in other directions they have monocular (single-eye) vision and, because the eyes do not move in the head, ducks must tip their heads to see in different directions. The eyeball is saucer-shaped when viewed from the front and round when seen from the side (although the skin surrounding the eye gives it an elliptical look). In a painting, the curvature of the eye into the head is shown by a shadow; this creates a believable-looking eye. The iris color of divers ranges from dark brown to golden yellow to red.

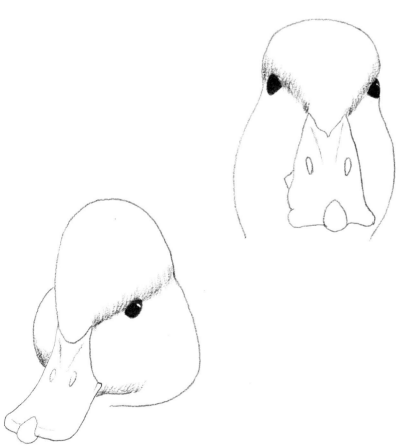

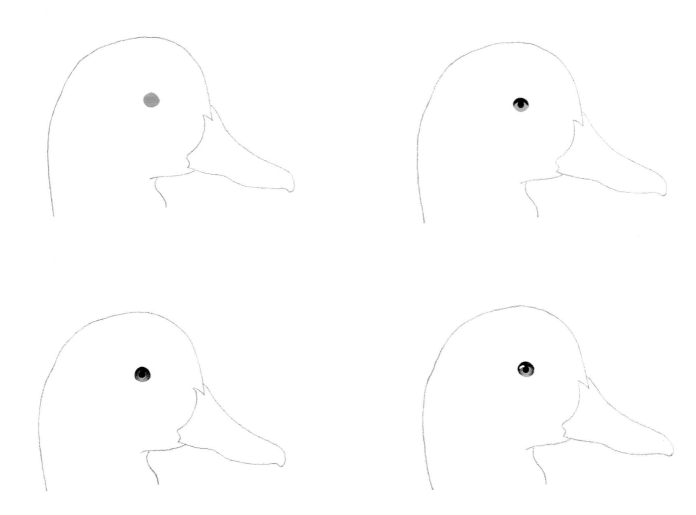

Painting the eye. *First the iris color is painted. Opaque black is used to paint the pupil and the shadow at the top of the iris. The shadow is then blended down into the iris to give it depth. An opaque white highlight adds "life" to the eye.*

7
Painting
Examples

Random Notes Prior to Painting

When following the painting examples, you will notice that at times certain adjustments are made to the picture in color, value, shape, and so on. This is the way a painting actually progresses: changes are always being made. These examples were not prepainted and then redone for this book. These are first-time examples, done so you could see the real process of bird painting, corrections and all. Very little may be learned from watching the painting of a flawless picture.

Plan ahead when beginning a painting; have at hand only those brushes, colors, and materials that you will need. Excess tubes, brushes, and whatever only add clutter when you need it least. Though the colors on your palette look organized when first squeezed out, don't be dismayed when it all seems a mess after a short time. Very few artists maintain a controlled palette. Have a scrap of watercolor board handy to test brushes for load and stroke, and a rag or paper towel to blot brushes. Give yourself clean water, brushes, all the other painting materials you may need, and time to paint.

All the examples were painted on cold press illustration board and the paints are gouache (designers colors). Winsor & Newton and Pelikan colors are used interchangeably, except in the case of raw umber, where the brand used is noted. (Winsor & Newton raw umber is yellower than Pelikan raw umber.)

These examples are painted in gouache but, with a few adaptations of technique, the same methods and colors may be used with acrylics. The variations in technique are noted in the text of the examples.

Drawings

Following the color painting examples are black-and-white line drawings of the individual ducks. By eliminating shading and individual feathers and only showing significant body patterns and major feather groups, their relationships to one another become more apparent as seen from various angles. The poses show diving ducks in different states of excitement from calm to very agitated. Head shape, body shape, and the relationship of the eye and bill are seen from some unusual angles. The drawings were done from photographs and specimens to ensure accuracy. These drawings will provide additional references to the form and attitudes of diving ducks and enable you to paint a realistic duck no matter what the pose.

Water

Water is the natural habitat of ducks, so it is important to understand some of its properties. Pure water is colorless—a condition that rarely appears in nature. Water usually has a color that may come from a variety of sources: plant life, dissolved materials, chemicals, or turbulence. Water also has another source of color: its surroundings. The surface acts as a mirror and reflects the sky, objects on the bank, or objects resting on the water. An absolutely calm surface would reflect a perfect image; any movement of the

water, however, distorts the image. Water and its reflected images must be studied carefully to produce a realistic rendering. In the painting examples the water and reflections are presented in a very simple, straightforward manner because the emphasis of this book is on painting the duck.

Red-breasted Merganser

Mergus servator

Diving ducks are not adept at walking on land and, among divers, mergansers are the least adept of all. Of the mergansers, though, the red-breasted merganser does the best on land. They are often seen standing on the ground or on logs with their bright orange-red legs exposed. Mergansers have great difficulty becoming airborne and must run quite a distance with much wing flapping before they achieve flight. Once in flight, they are a sight to behold; almost noiselessly, they fly rapidly and very close to the water surface with their necks outstretched before them.

Male red-breasted mergansers are easy to identify; they have an iridescent green crested head, white neck collar, chestnut-colored breast, white flanks, and orange-red bill and feet. They also have an unusual group of large black-and-white feathers at the back of the breast. The male red-breasted merganser is an interesting bird to paint because of its varied patterns and colors.

The palette used is Pelikan raw umber, ivory black, white, yellow ochre, burnt umber, ultramarine blue pale, cadmium red pale, cadmium orange, brilliant green, and sap green yellowish. The brushes used are #3 and #1 Kolinsky sable rounds. Unless otherwise noted, the #3 round will be the brush used.

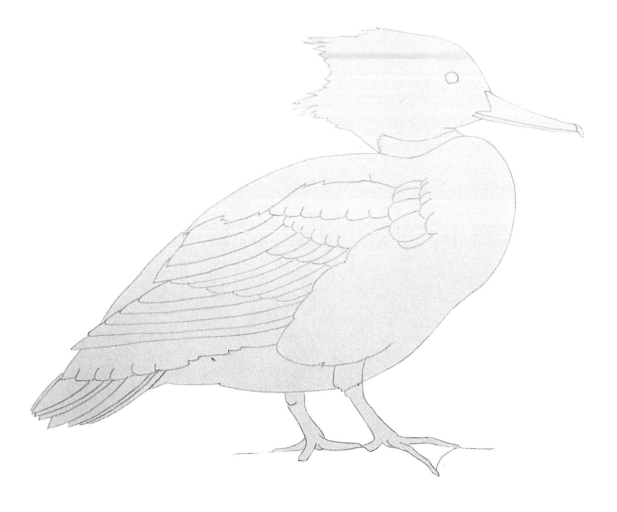

The drawing of the red-breasted merganser is transferred to the painting surface.

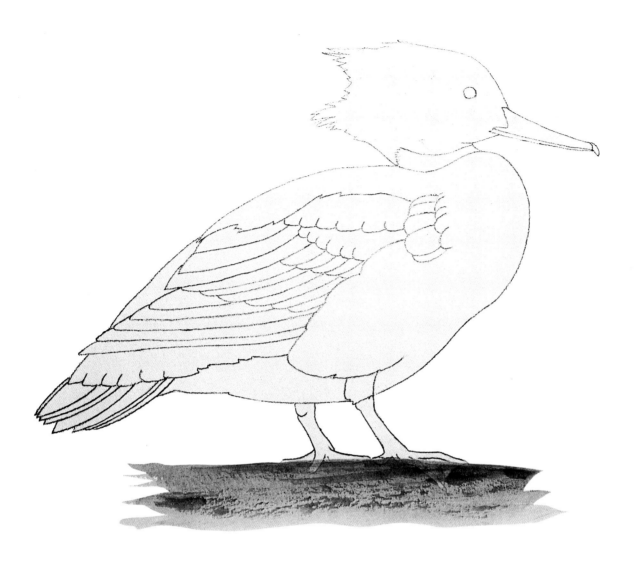

Liquid masking is painted on the feet. When the masking is dry, thin raw umber is washed over the foot area to indicate a base, in this case a log. When the wash is dry, opaque raw umber is drybrushed over the base coat to show texture.

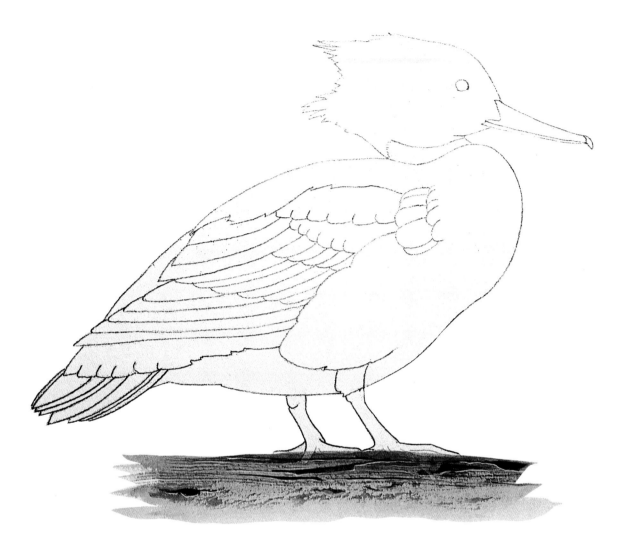

Opaque black is used to paint in
some random cracks in the log. The
same color defines deep shadows
on the dry-brushed raw umber and
opaque white adds highlights in
the shadow areas.

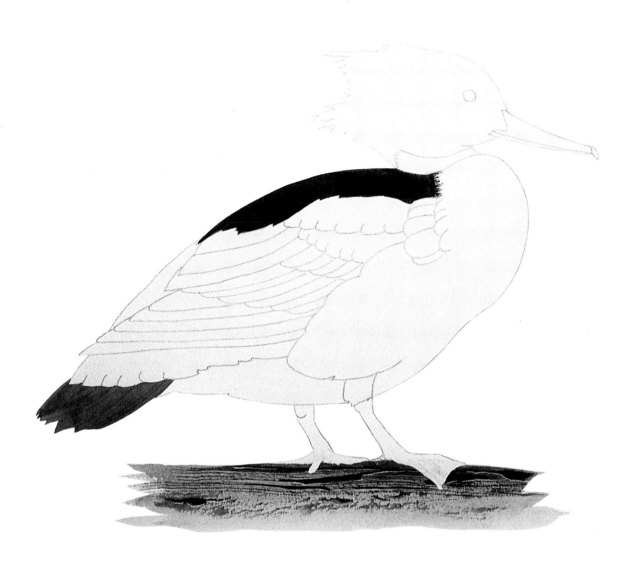

The masking is removed from the feet. A thin white wet-in-wet wash is painted over the lower breast, belly, flanks, and undertail coverts, and very thin black is painted on the tail. Opaque black is added on the mantle and back; the black is split-brushed where the mantle meets the breast to produce an irregular edge.

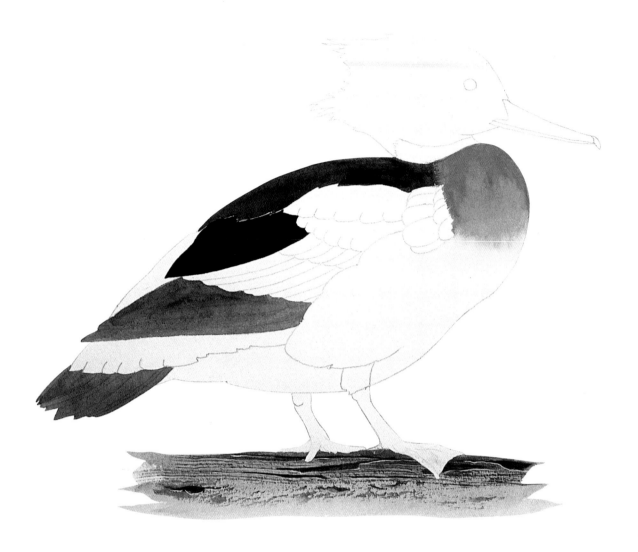

Opaque black is painted on the tertials, while very thin black is painted on the primaries and tail feathers. A thin mixture of white, yellow ochre, and burnt umber is washed wet-in-wet on the upper breast. Where the wash meets the black back, it is splitbrushed, and where it meets the white, it is glazed and graded down with a clean damp brush.

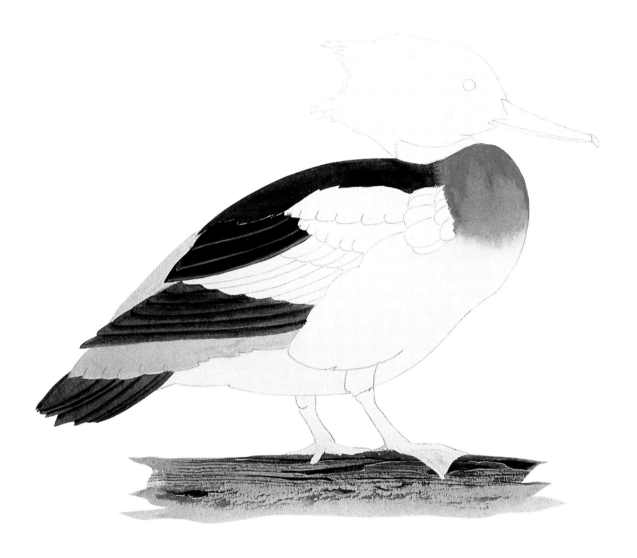

White and black are mixed to a light gray and painted over the back and upper-tail coverts. Opaque white paints in the lower white scapulars, wing coverts, and secondaries. An opaque mixture of white and ultra-marine blue pale is painted along the bottom edge of each tertial, then glazed and blended back into the black with a clean damp brush. This same technique is used with opaque black to show the shadows between the tail feathers and primaries.

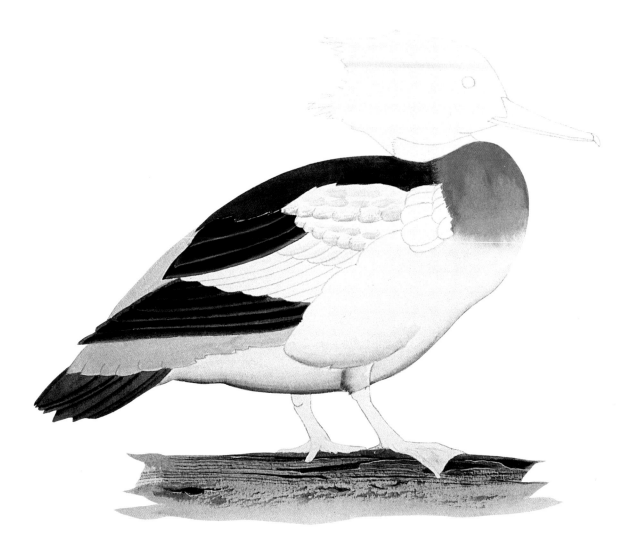

The primaries are two colors: the leading edge is black and the trailing edge is gray, so more opaque black is added to the leading edge of each primary. Form and shading are added to several of the white areas. The white scapulars and covert edges are lightly brushed with a pale mixture of white and ultramarine blue pale. The belly and flank are shaded by turning the painting upside down and painting a line of black along the darkest edge. The black is then glazed and graded with a clean damp brush.

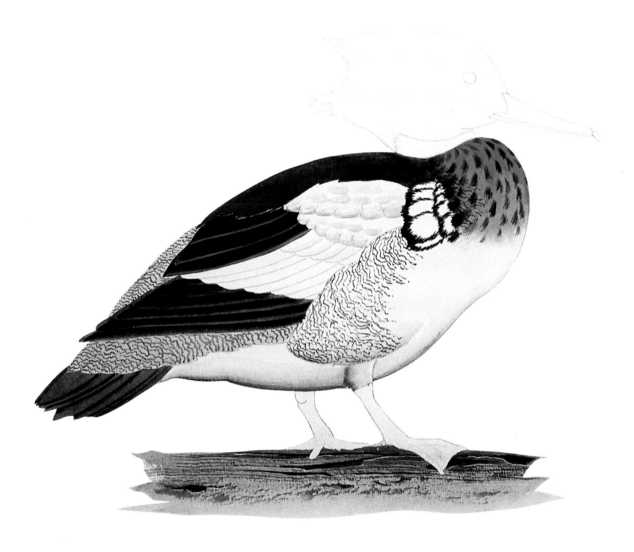

Vermiculation is detailed on the back, upper-tail coverts, flank, and rear of the breast with black in the #1 round. Opaque black is also used to detail the patterns on the breast and to outline the large feathers at the back of the breast.

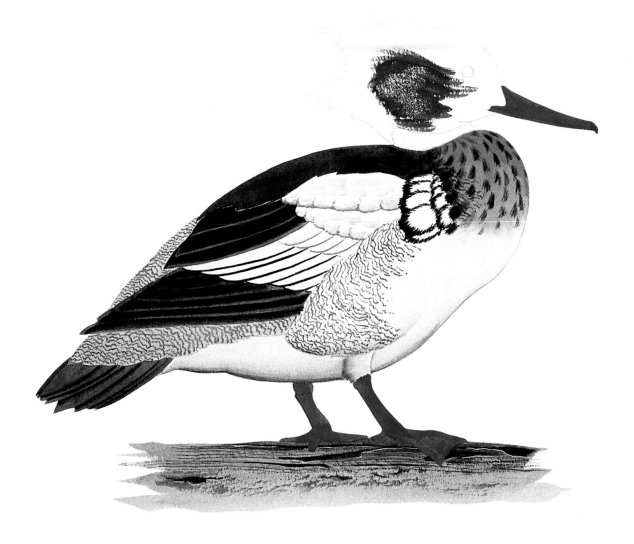

The bill, feet, and legs are painted
with a mixture of cadmium red
pale, cadmium orange, and burnt
sienna. The secondaries are detailed
with opaque black edges in the #1
round. The edges of the white cov-
erts are defined with black and
white mixed to a medium gray. Bril-
liant green is painted on the head
where the iridescence will show.

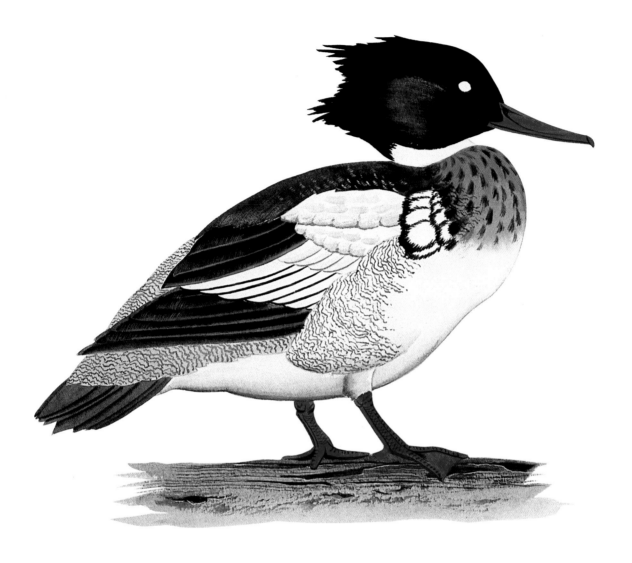

Opaque black is painted on the head and, where it meets the green, it is splitbrushed to make an irregular edge. Ultramarine blue pale and white are mixed and used in the splitbrush to show light feather edges on the dark back, tertials, and primaries. A mixture of black and burnt umber is painted in to show rough shadows on the bill and feet.

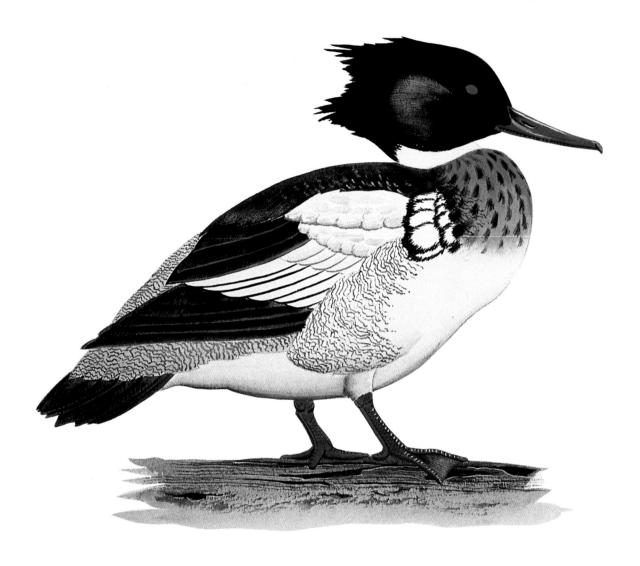

A clean, damp brush softens and
blends the rough shadows on the
bill and feet. Opaque black in the #1
round details in the nostrils and
lamallae on the bill and the nails on
the feet. White is used to highlight
areas on the bill and feet. Opaque
sap green yellow is splitbrushed on
the green of the head to show irides-
cence. Cadmium red pale paints
in the iris of the eye. Opaque black
in the splitbrush adds feather breaks
on the tail. (Acrylic note: The
shadows on the bill and feet must be
blended while the paint is still wet.)

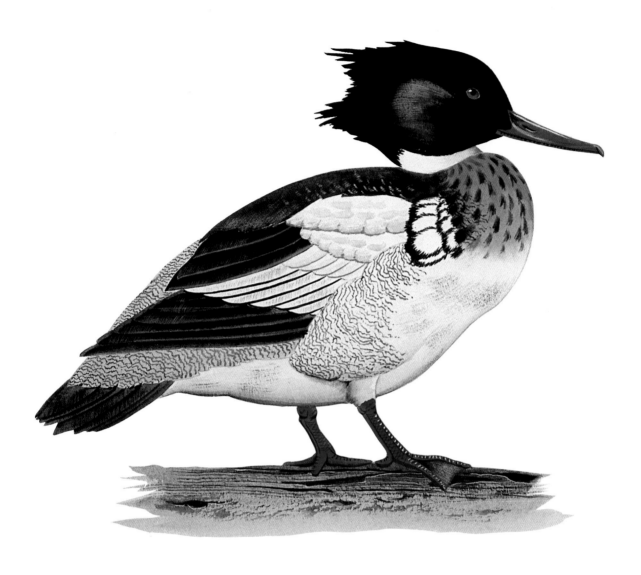

Black and white are mixed to a light gray to detail the eye ring. This same mixture is used to splitbrush featheration on the secondaries, to add form to the breast, and paint a light shadow on the neck. Opaque black paints in a shadow at the bottom of the flank to emphasize the leg inserting into the body. Opaque black also paints a shadow at the top of the iris and forms the dark pupil. An opaque white highlight in the eye completes the red-breasted merganser.

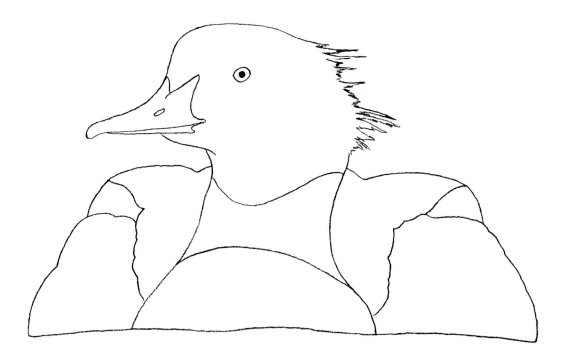

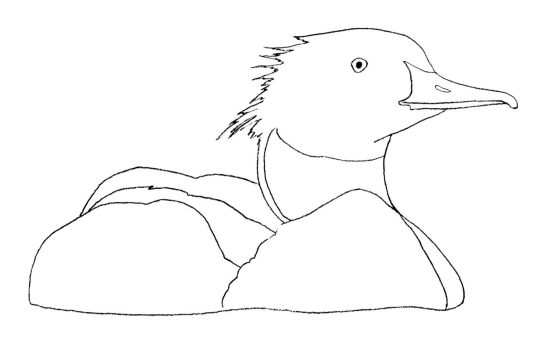

red-breasted merganser

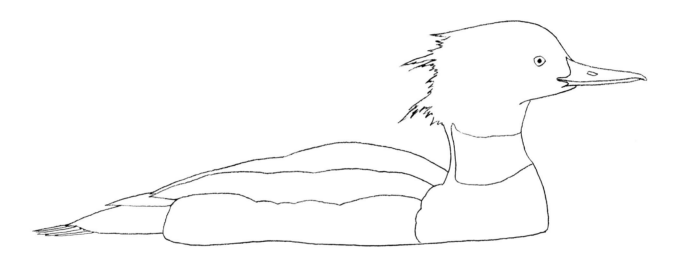

red-breasted merganser

Greater Scaup

Aythya marila

Greater scaups usually feed offshore in large "rafts." Although plants provide their main sustenance, they may also feed on shellfish and crustaceans. Usually diving to a depth of around twenty feet, they can remain underwater for up to one minute. Very often greater scaups associate with lesser scaups, and separating the greater and lesser scaups can be a challenge. Close up and in excellent light there is no problem: the greater scaup's head iridesces green while the lesser's iridesces purple. At a distance, however, problems arise. Greater scaups often look larger and bulkier, but be aware that there are small greater scaups and large lesser scaups. In flight, though, it's a different story because the scaups' wing patterns are easy to separate. The wings of the lesser scaup have only white on the secondaries, while the greater scaup has white on both the secondaries and some of the primaries.

The palette used is white, ivory black, Pelikan raw umber, Payne's gray, brilliant green, ultramarine blue pale, and cadmium yellow pale. The brushes used are #3 and #1 Kolinsky sable rounds and #4 sableline filbert. Unless noted otherwise, the brush used is the #3 round.

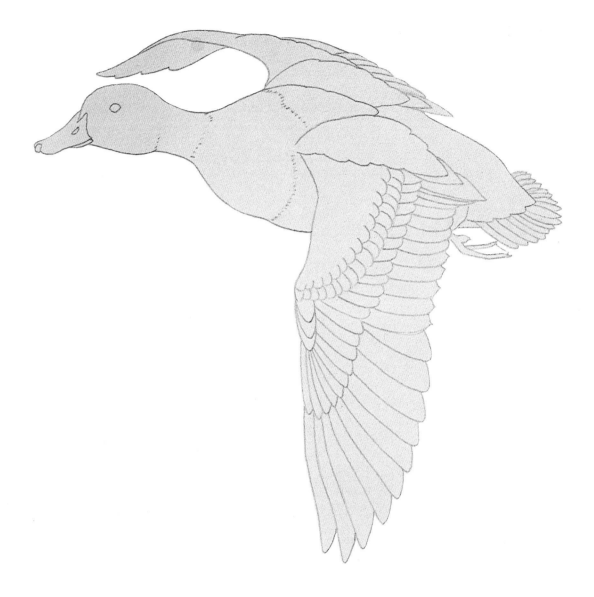

The drawing of the greater scaup is transferred to the painting surface.

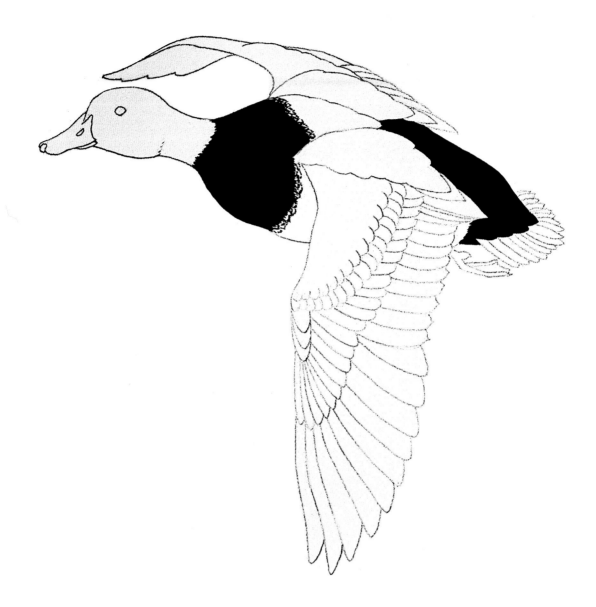

Thinned white washes in the scapulars, back, belly, and secondaries. Opaque black paints in the mantle, upper-tail coverts, and breast. To begin the vermiculation, tiny irregular black lines are detailed where the black of the breast and mantle meet the white.

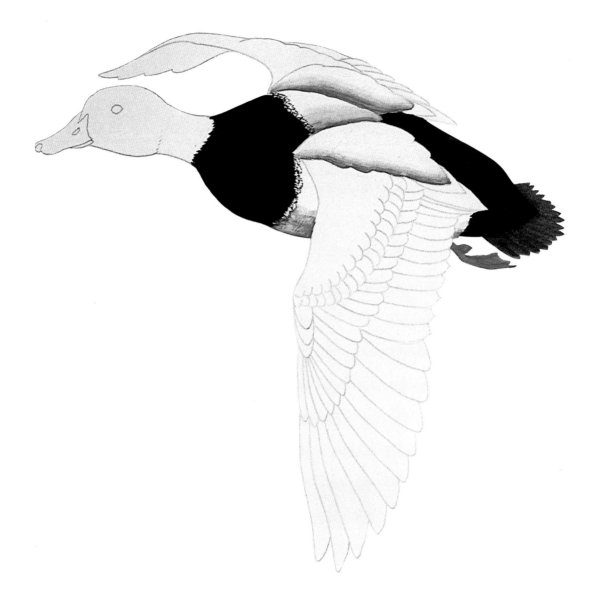

The painting is turned upside down so black may be glazed over the bottom of the white areas to add shading and form. A thin line of black is painted on the area to be darkest and glazed and graded with a clean, damp brush until a rounded effect is achieved. The painting is then righted, and the tail is painted in with a thin mixture of black and raw umber. The foot is colored with a dark mixture of black and white.

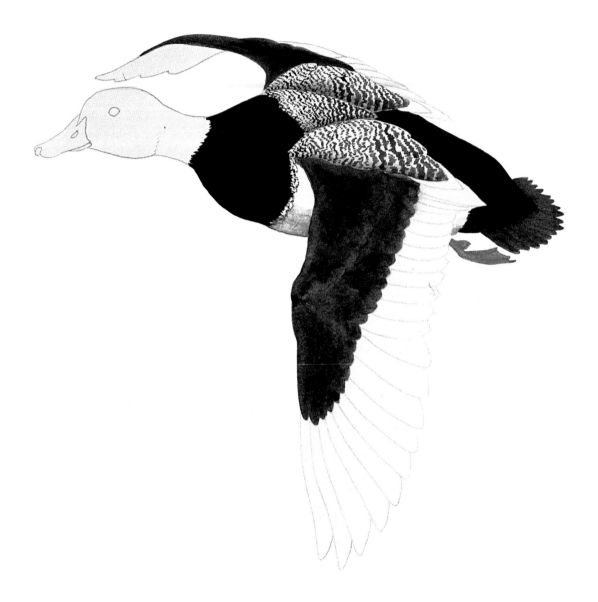

Opaque black in the #1 round is used to detail the vermiculation on the back and scapulars. A thin wash of mixed black and raw umber is painted on the wing coverts.

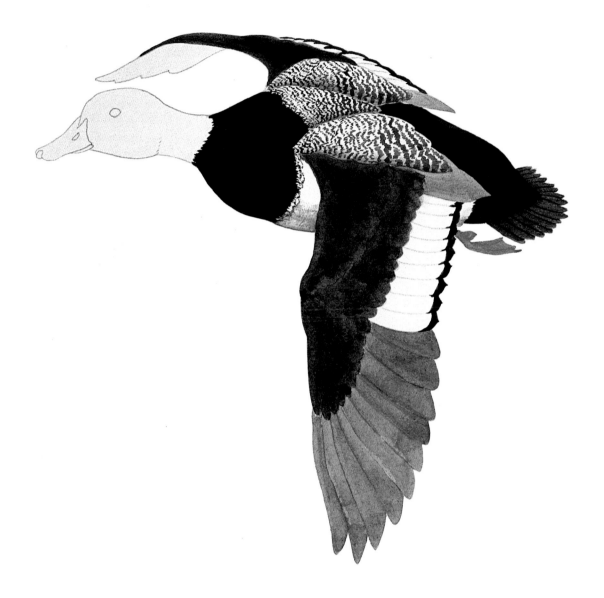

The primaries and tertials are individually painted with very thin black. The tips of the secondaries are painted with opaque black. A thin black shadow line is detailed under each tail feather.

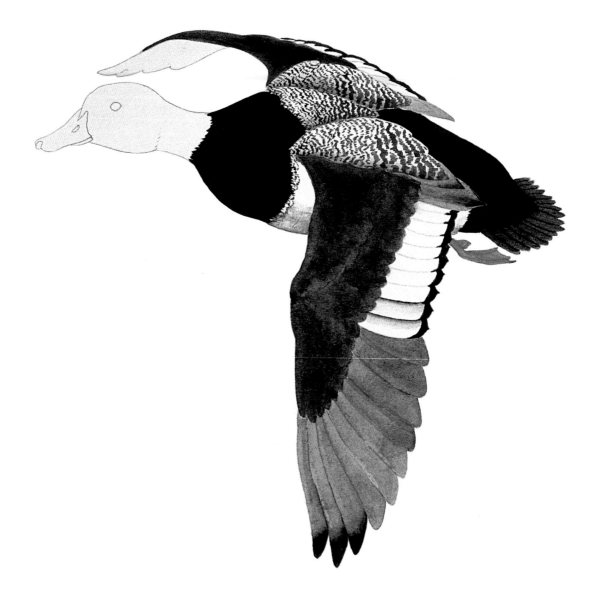

Next is a series of rather tedious glazing and grading steps on the tips of the primaries and tertials and between the white secondaries. Each feather must be painted and shaded individually: black is painted where the area is to be darkest, then glazed and graded with a clean damp brush. (Only a few of the feathers were done in this step.)

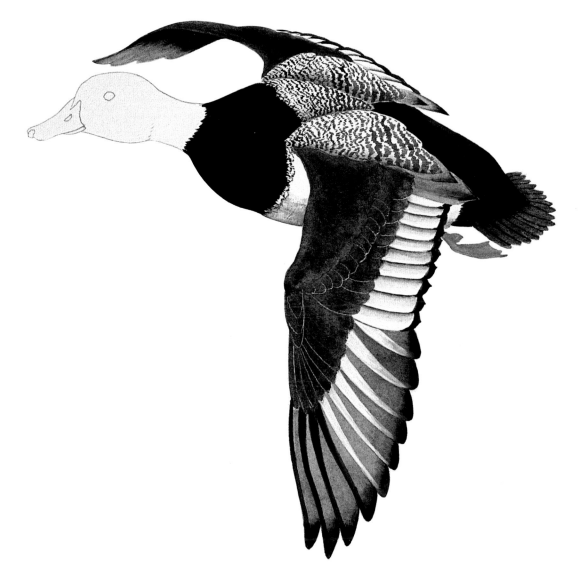

The glazing and grading on the wing feathers is completed. The feather coloration on the leading edge of each primary in front of the feather shaft is now begun. The leading edge is thinned black for the first four primaries; for the remaining primaries it is opaque white, which is blended into the blade tips. A graded wash is done on the under-portion of the far wing. If the traced, wing covert feather lines are not visible under the previously applied dark wash, reposition the original tracing and retransfer them on top of the wash.

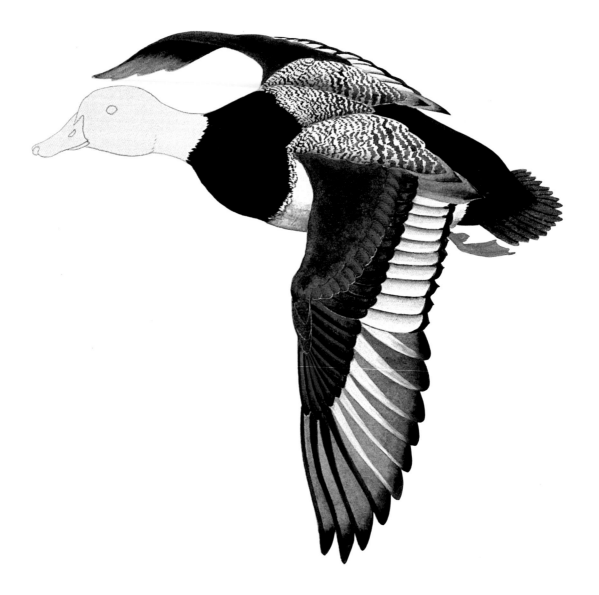

*Thinned black is lightly brushed
on the leading edges and tips of the
primary and secondary coverts.
Opaque black details a shadow line
under each secondary covert. A thin
mixture of Payne's gray and white is
lightly painted at the back of each
primary covert and on the edges of
the median coverts.*

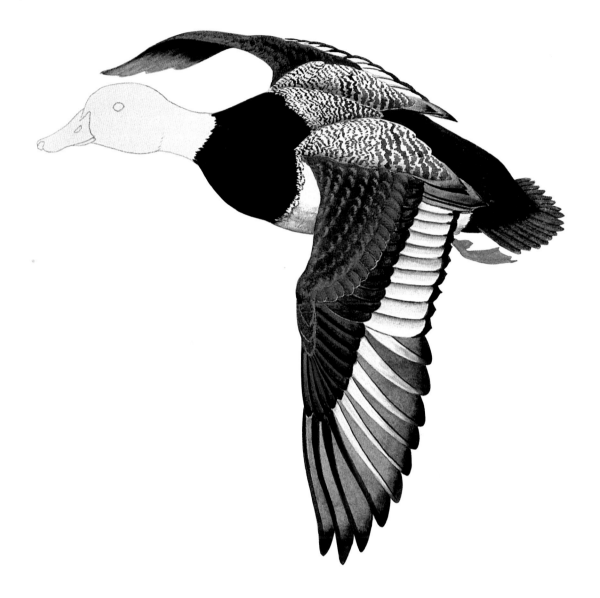

An opaque mixture of white and Payne's gray is loaded in the #4 filbert to tip in the feather edges of the remaining wing coverts. This same color is used in the splitbrush to touch in the feather edges on the tail feathers and the alula of the wing. Opaque black in the #1 round details feather shafts on the primaries and shadows under each tertial.

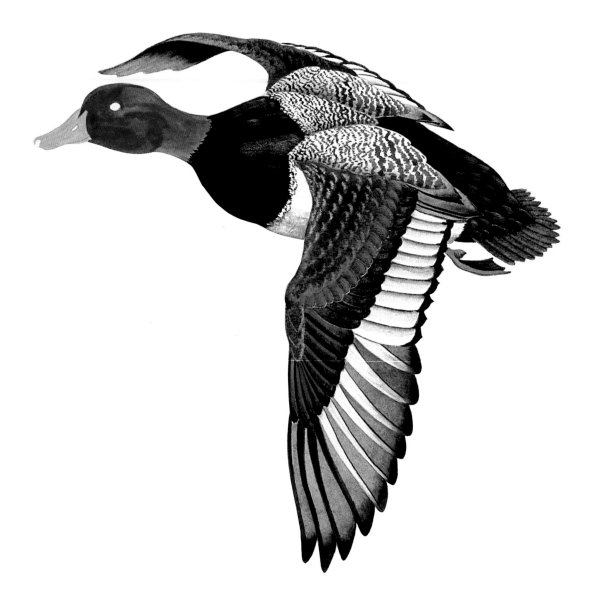

Thinned brilliant green is washed on the head and neck. An opaque mixture of white and ultramarine blue pale paints in the bill and is used in the splitbrush to show light feather edges on the upper-tail coverts. Opaque black in the #1 round adds detail to the foot.

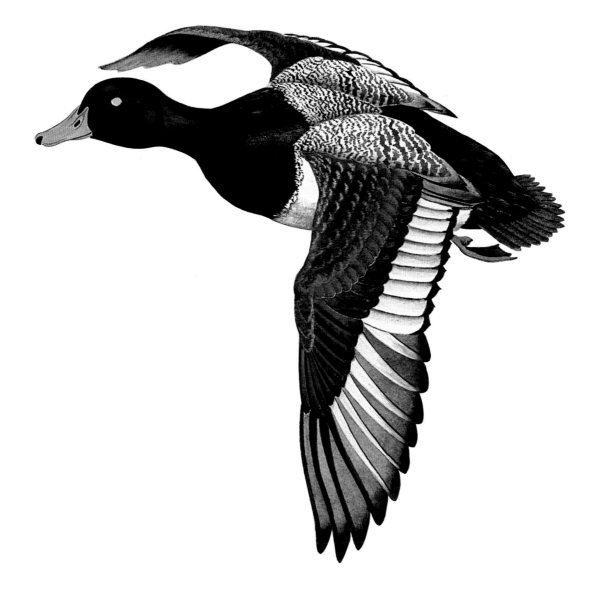

Opaque black paints in the dark areas of the head and neck, letting green areas show where iridescence would occur. Where black meets green, the splitbrush is used to indicate irregular edges. Opaque black also details in the nostril and nail on the bill. The bill shadows are an opaque mixture of ultramarine blue pale, white, and black. Opaque cadmium yellow pale is painted in the iris of the eye.

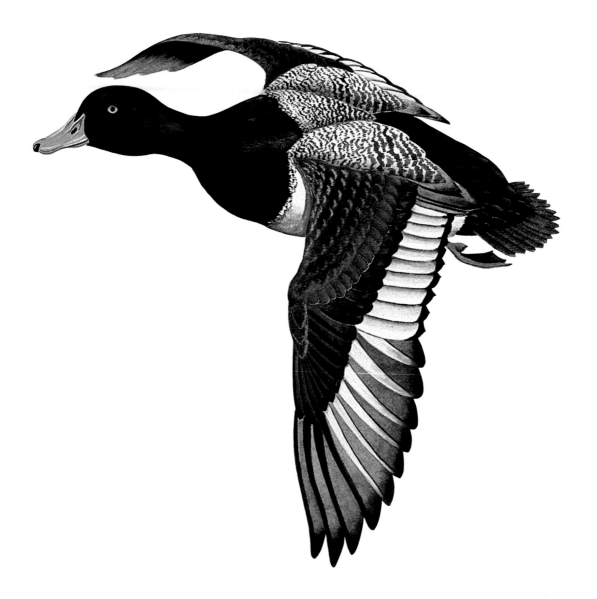

*Opaque black in the #1 round
details the eye pupil. A tiny amount
of thin black paints in a shadow at
the top of the iris, which is blended
down into the yellow, and paints in
a hard shadow on the white belly at
the front of the near wing to sepa-
rate the outstretched wing from the
body. Opaque white in the #1 round
highlights the bill.*

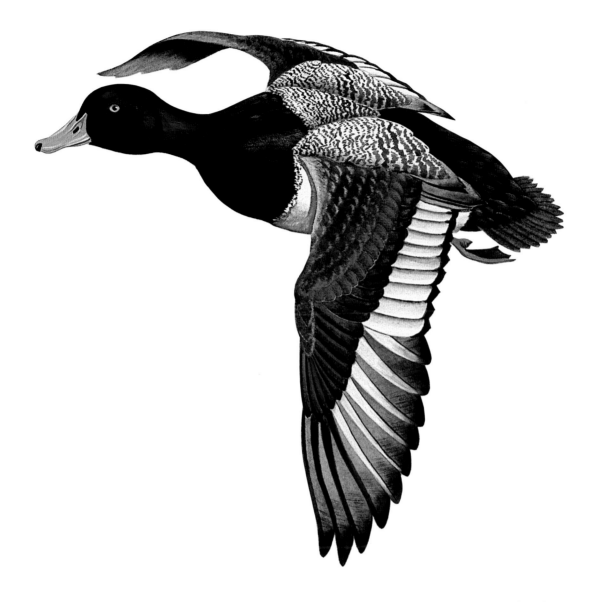

It is determined that there is not enough contrast between the belly shadow and the leading edge of the near wing. An opaque mixture of white and Payne's gray is lightly splitbrushed on the leading edge of the wing until separation is achieved. Opaque black in the split-brush adds featheration to the tips of the primaries. The greater scaup comes to life with an opaque white highlight in its eye.

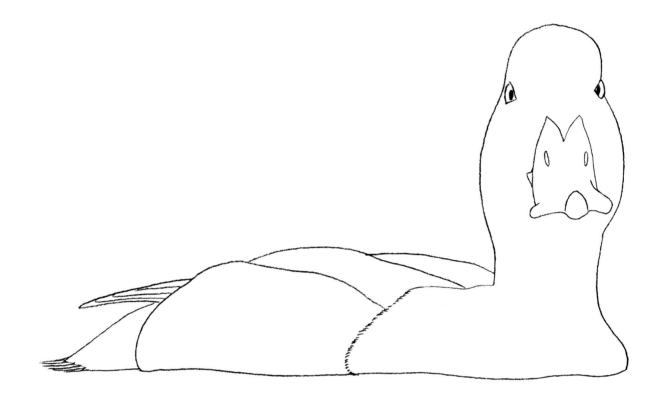

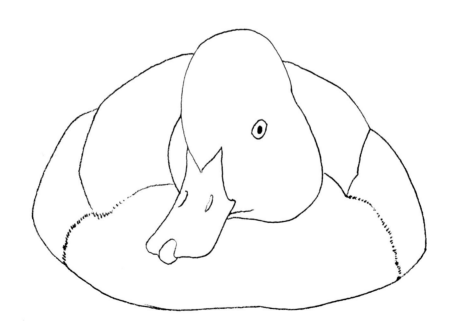

greater scaup

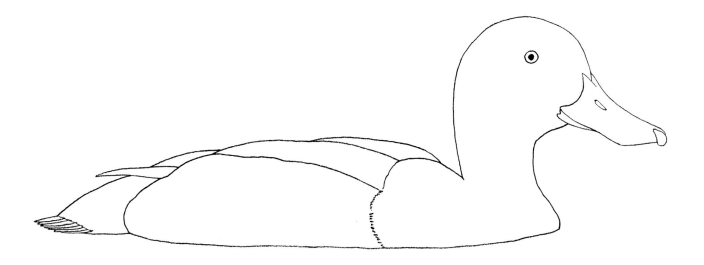

greater scaup

Redhead

Aythya americana

Redheads have a split personality when it comes to associating with other diving ducks: during migration they stay to themselves flying in a loose V-shaped flock, but on the water they seek the company of other divers and are usually seen with scaups and canvasbacks. The basic body patterns of all these ducks are similar and at a distance they can be difficult to identify. When seen close up, though, it's easy to separate the males of the species; the canvasback has a distinctive sloping head profile, and the almost black color of the scaup's head contrasts with the reddish chestnut color on that of the redhead.

Redheads feed mainly in the morning and evening, usually quite a way from shore, though they may feed in shallow coastal ponds during winter. Aquatic vegetation is their dietary mainstay.

Redheads are distinctive in both patterns and color. When painting the redhead, pay close attention to the color of the head and to all the vermiculation detail on the sidepocket and scapulars.

The palette used is white, ivory black, ultramarine blue pale, Pelikan raw umber, burnt sienna, yellow ochre, raw sienna, cadmium yellow pale, and violet. The brushes used are #3 and #1 Kolinsky sable rounds and #4 sable-line filbert. Unless otherwise noted, the #3 round is the brush used.

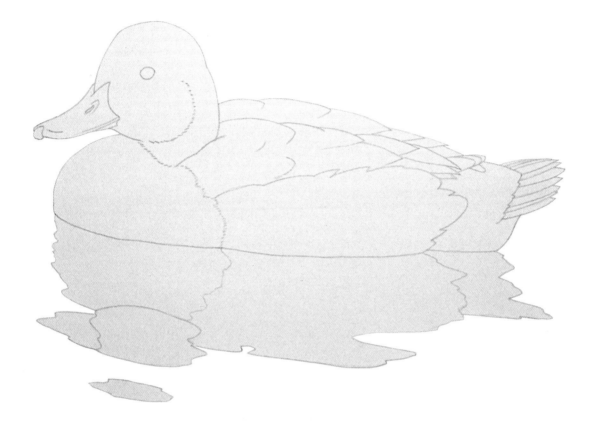

The redhead drawing is transferred to the painting surface.

Liquid masking is painted over the bottom part of the duck. When it is dry, a thin mixture of black and ultramarine blue pale is painted wet-in-wet with the half-inch flat over the lower part of the painting to show water. While the wash is still wet, opaque white and black are alternately painted to produce water highlights and shadows.

The masking is removed, and an opaque mixture of white and black is painted on the bottom undertail coverts. The tail, tertials, and primary tips are painted with an opaque mixture of black, white, and raw umber. The head's base color is a wash of mixed burnt sienna and yellow ochre. Thin white is then washed wet-in-wet on the flank and scapulars.

To paint a series of graded washes showing shade and form on the flank and scapulars, turn the picture upside down, then paint a thin line of black where the shading is to be darkest. This black is glazed and graded over the white with a clean, damp brush until blended. Each area is done separately.

*Opaque black in the #1 round
details the vermiculation on
the sidepocket and begins the ver-
miculation on the scapulars.*

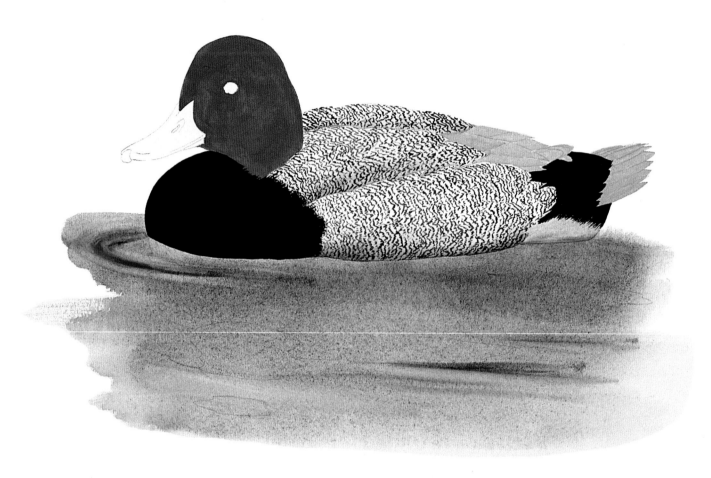

The vermiculation on the scapulars is completed. Opaque black is painted on the breast, upper-tail coverts, and remaining undertail coverts. Where these black areas meet other colors, the splitbrush is used to show irregular feather edges.

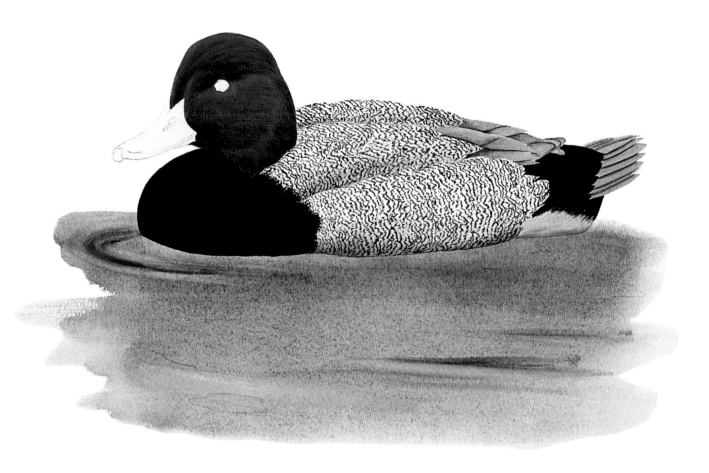

To separate the feathers of the tertials, primaries, and tail, a black shadow line is painted under each feather and blended down with a clean damp brush. Dark shading and featheration on the head is put in by splitbrushing with an opaque mixture of black and raw umber.

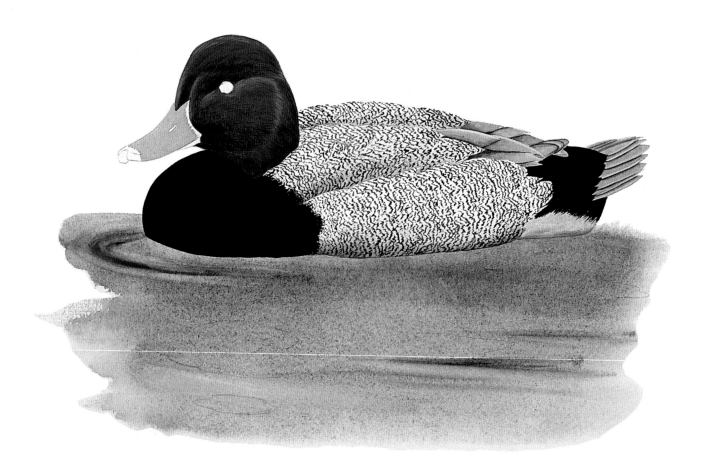

Highlights on the head are indicated by splitbrushing an opaque mixture of raw sienna and burnt sienna. The blue of the bill is a mixture of ultramarine blue pale, white, and a small amount of black.

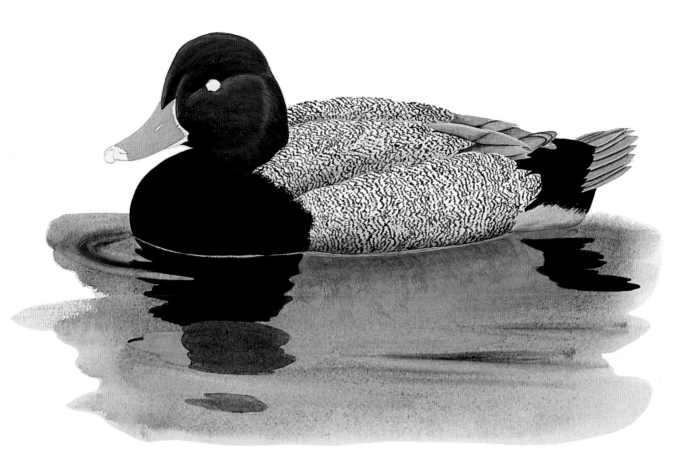

It is decided to put the reflection in now, although it could be done at any time. The reflection is made by a series of thin washes in the basic colors of the redhead. The water in the painting is quite agitated so the reflection of the vermiculation is obscured.

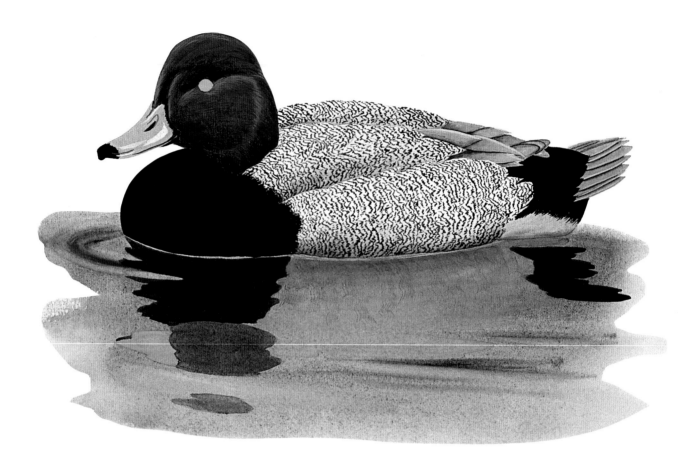

Opaque black details the black
markings of the bill. Opaque white
roughs in the highlights on the bill,
and a dark mixture of ultramarine
blue pale, white, and black paints in
the shadow areas. The iris of the eye
is painted with an opaque mixture
of raw sienna and cadmium yellow
pale.

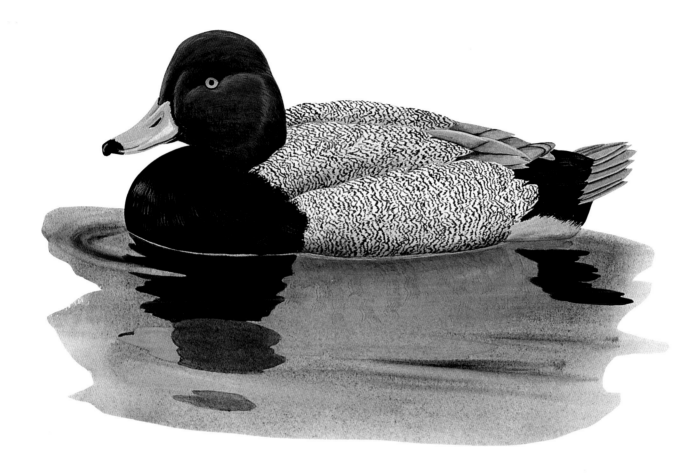

A tiny amount of violet is mixed with the iris's cadmium yellow pale and raw sienna; this dark shade is then used to detail a shadow area at the top of the eye. Opaque black details the pupil and outlines the eye. The highlights and shadows of the bill are softened and blended with a clean damp brush. An opaque mixture of white and ultramarine blue pale is used in the split-brush to add feather highlights to the breast and upper-tail coverts. (Acrylic note: The highlights and shadows of the bill must be blended while they are still wet.)

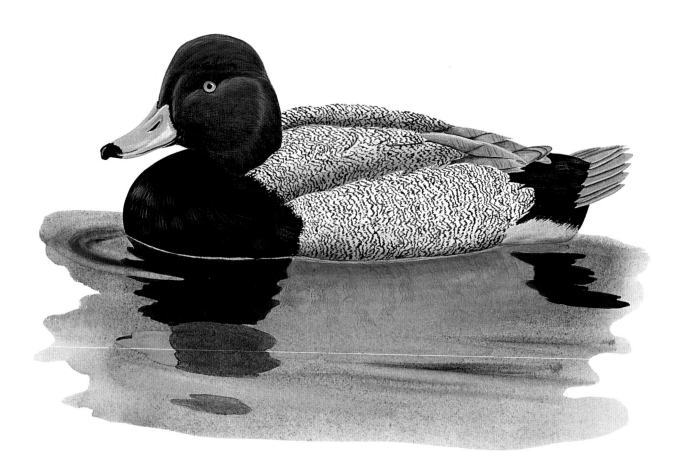

It is determined that there is not enough shading on the flanks and scapulars, so another series of graded washes is applied. Light splitbrushing with thin black adds featheration to the tertials. Finally, an opaque white highlight adds detail to the eye.

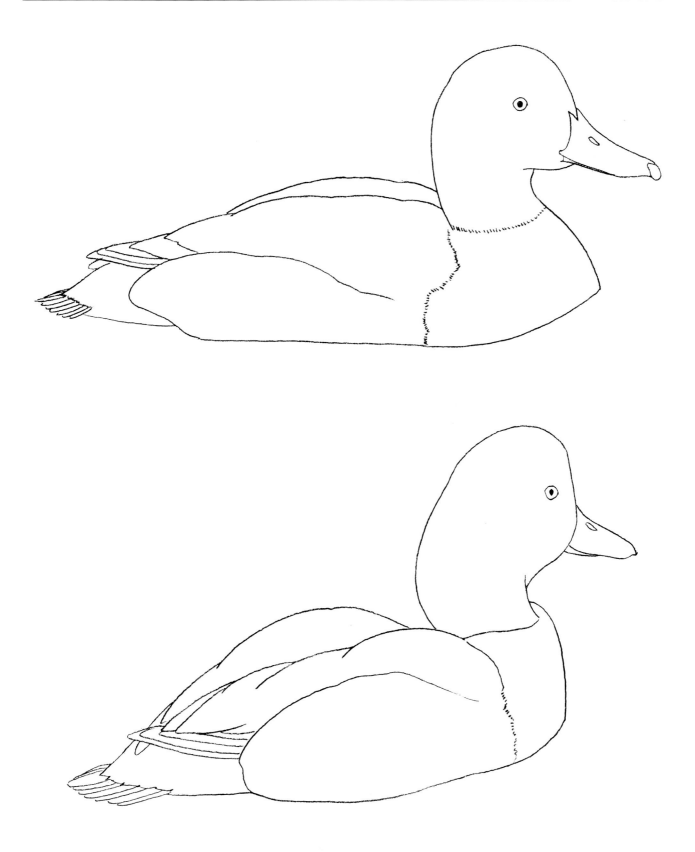

redhead

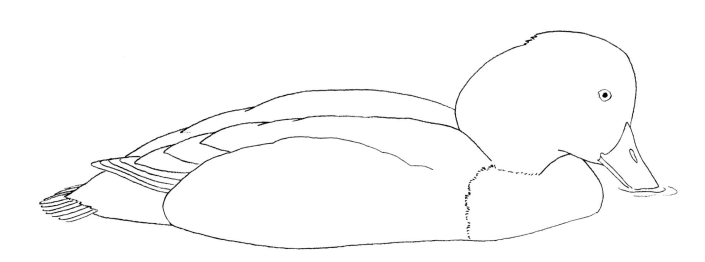

redhead

8
Practice
Birds

Ring-Necked Duck

Aythya collaris

Active divers, ring-necked ducks feed almost exclusively on aquatic plants. They can dive as deep as forty feet, but they prefer to feed in more shallow waters. Of all the divers, the ring-necked is most closely associated with the year-round use of fresh water because of its fondness for wooded ponds, swamps, and marshes for feeding and nesting areas. Their ability to rise quickly from the water permits the use of these small bodies of water.

At a glance, it would seem that ring-necked ducks would be confused with scaups. But a closer look reveals that the ring-necked duck has a black back, not gray as in the scaups, and the white side extends in front of the wing as a small crescent. The ring-necked duck does have a dark chestnut-colored neck ring, but it is extremely difficult to see, even when closely viewed. Because of the bold rings on its bill, a more appropriate name would be the ring-billed duck.

A ring-necked duck's black back may show a green iridescence, and, in good light, the slightly crested head may show a violet iridescence. Painting the ring-necked duck involves detailing the correct shapes and patterns and painting the iridescence with a light hand.

Palette: ivory black, white, Pelikan raw umber, Vandyke brown, ultramarine blue pale, violet, and cadmium yellow pale.

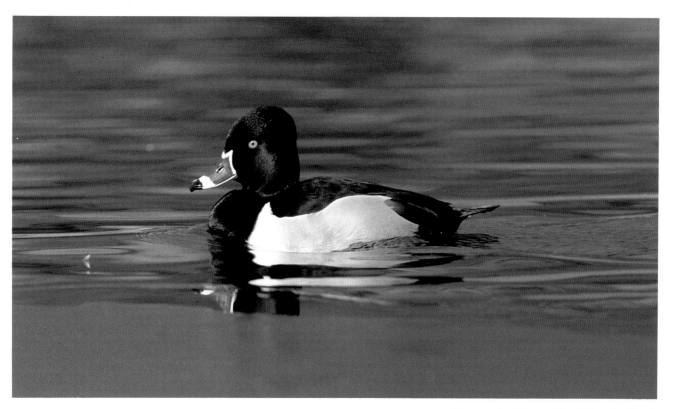

Ring-necked Duck (Rod Planck photo)

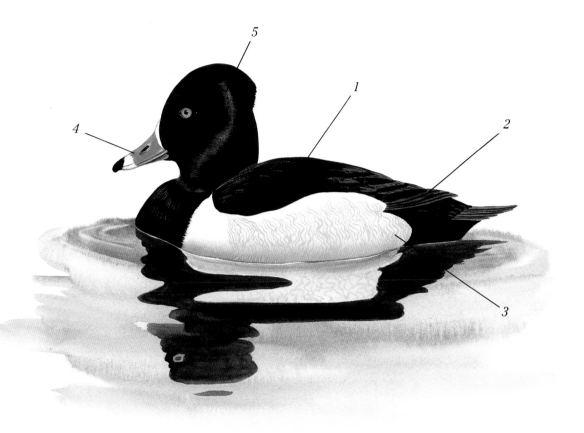

1. *Dark areas are painted opaque ivory black and highlighted with the splitbrush using a mixture of white and ultramarine blue pale.*

2. *Wings and tails are filled in with a mixture of white, raw umber, and black, then shaded with opaque black.*

3. *Opaque white shaded with a graded and glazed wash of thin black is used on the sidepocket. Vermiculation is detailed with a light mixture of white and black.*

4. *The blue of the bill is provided with a mixture of white, black, and ultramarine blue pale.*

5. *To show iridescence, violet is applied, then opaque black is painted over the remainder of the head; where the black meets the violet it is splitbrushed to show an uneven edge. The violet is then highlighted with white and violet mixed in the splitbrush. The eye is a mixture of yellow ochre and cadmium yellow pale.*

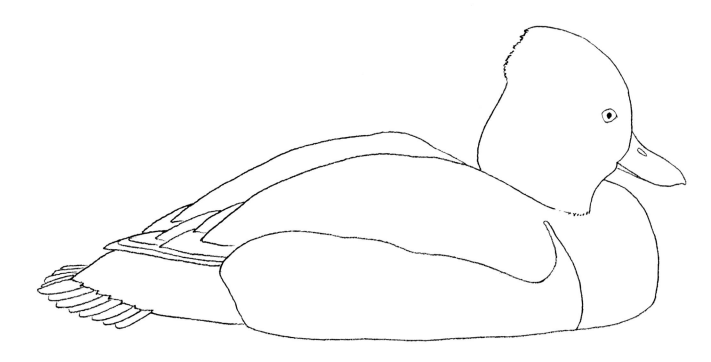

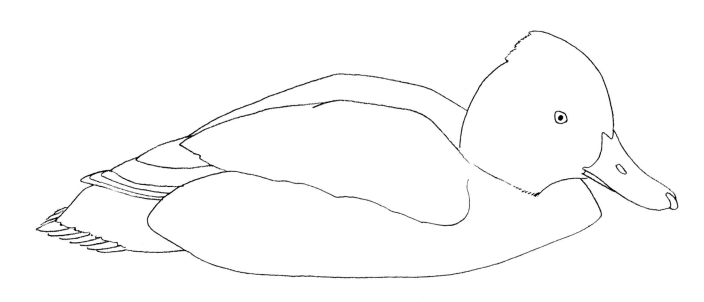

ring-necked duck

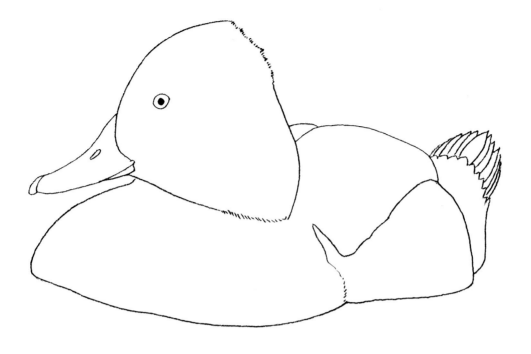

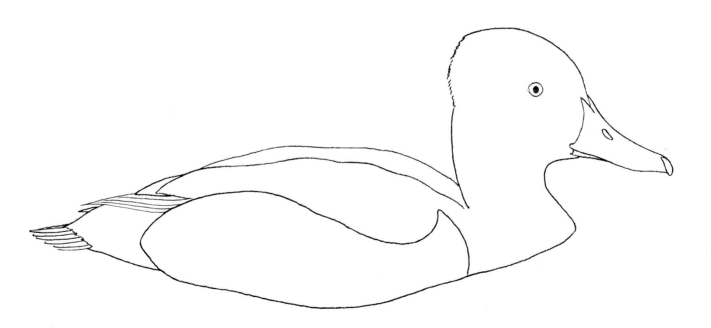

ring-necked duck

Bufflehead

Bucephala albeola

"Constant" and "motion" are the two words that most accurately describe the behavior of the tiny bufflehead, the smallest of the diving ducks. Buffleheads are always swimming or diving, disappearing quickly beneath the surface to pop up seconds later. While feeding on underwater plants and seeds, they also eat large quantities of aquatic insects and snails. Because of their ability to rise quickly from the water they are able to frequent small wooded ponds and marshes. Their favored nesting sites are dead trees and logs near these areas, and their favorite nest is an abandoned flicker hole.

At a distance male buffleheads appear to be a study in black and white, but a closer look reveals a glossy dark back and a head that boasts iridescent green and violet and a white patch that extends around the back of the head. These perky ducks usually float high on the water, so the key to a bufflehead painting is not only to paint the colors and patterns but also to capture their spirit.

Palette: brilliant green, violet, ivory black, white, ultramarine blue pale, and Pelikan raw umber.

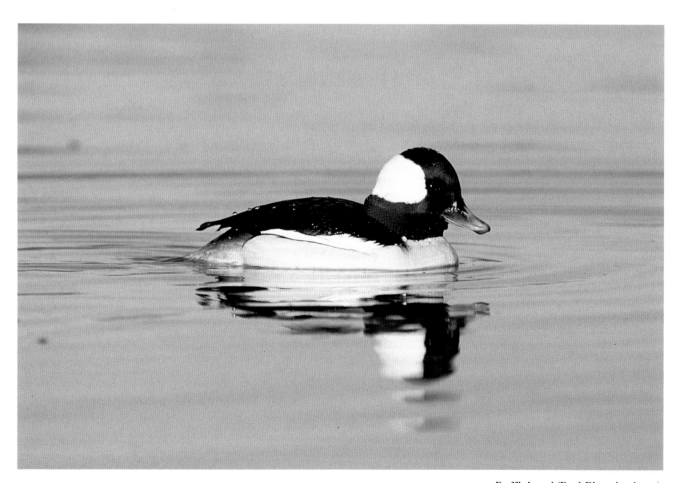

Bufflehead (Rod Planck photo)

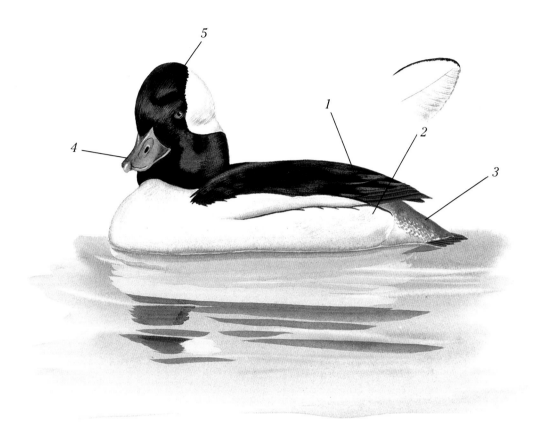

1. Opaque black covers the large back area. A mixture of ultramarine blue pale and white is splitbrushed lightly over the black to produce a glossy look.

2. The breast, sides, and side-pocket are opaque white shaded at the bottom with thinned ultramarine blue pale, which is glazed and graded over the white. The ultramarine blue pale is then used in the splitbrush to add more shading. The large flank feathers are edged with opaque black.

3. Upper-tail coverts are thinned raw umber, which is dabbed at the edges to create an irregular blend with the white.

4. Very thin black provides the base color of the bill; opaque black adds shading to the bill and opaque white adds highlights.

5. Violet and brilliant green are painted in iridescent areas. Dark is provided with opaque black, which is splitbrushed where it meets the areas of iridescence. The white patch on the head is opaque white shaded with ultramarine blue pale in the splitbrush. The iris of the eye is thin raw umber.

bufflehead

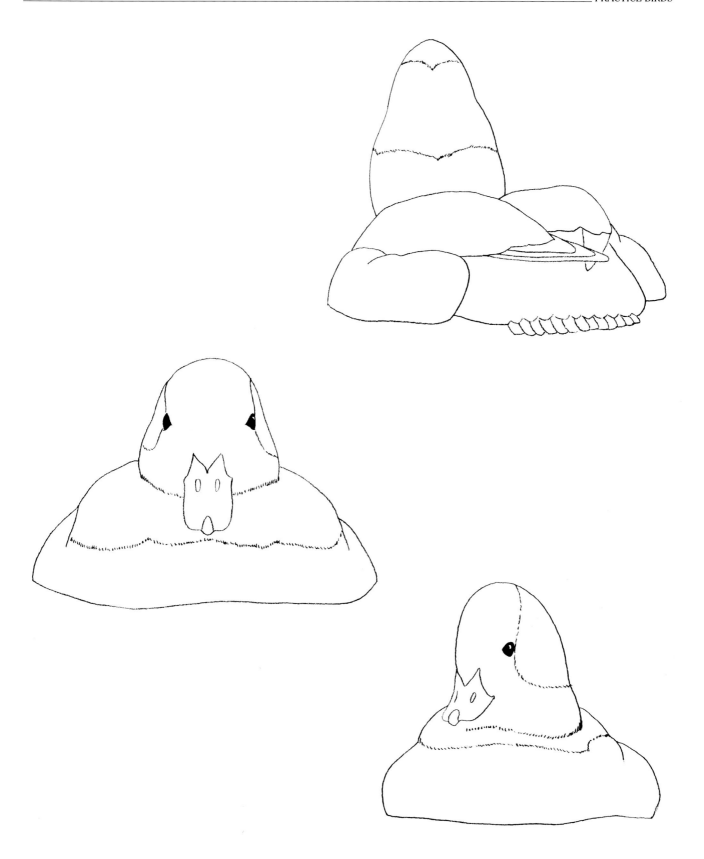

bufflehead

Hooded Merganser

Lophodytes cucullatus

Unlike other mergansers, the hooded merganser can lift directly from the surface of water or land without running. Thus, they are able to frequent small ponds, marshes, and swamps—the same habitat used by wood ducks with which hooded mergansers compete for nesting sites in old trees and snags. Hooded mergansers eat fish, as do other mergansers, but they seem to prefer aquatic insects and crustaceans. When their summer feeding areas freeze over, they move to fast-moving streams and rivers.

The male hooded merganser is spectacular, with its dark crested head boasting a large white patch, complimented with black bars on a white breast, large black and white tertials, and vermiculated chestnut flanks. Painting the hooded merganser should present no particular problems, just be aware that there is some blue-black glossy detail on the black areas and some blue-gray detail on the white areas. The vermiculation on the flanks must be painted carefully so it is not too bold against the base chestnut color.

Palette: ivory black, white. ultramarine blue pale, Pelikan raw umber, yellow ochre, burnt sienna, and cadmium yellow pale.

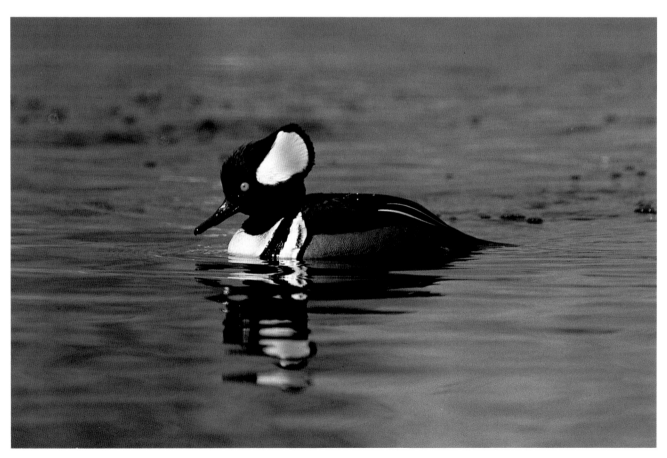

Hooded Merganser (Rod Planck photo)

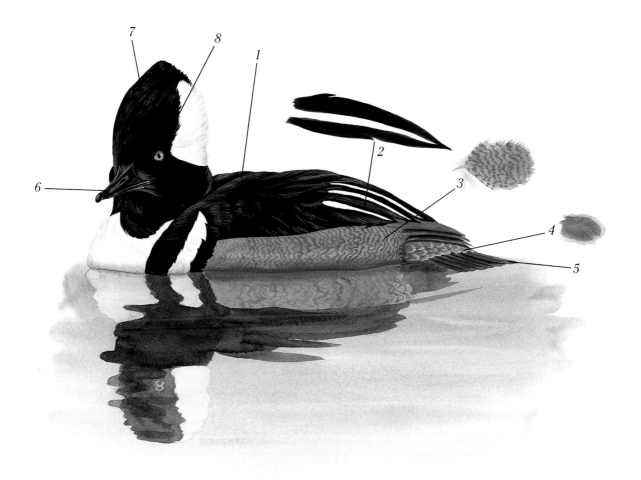

1. Opaque black is splitbrushed with a mixture of white and ultramarine blue pale to delineate dark areas and to show feather detail.

2. The tertials are large, opaque black feathers with opaque white centers.

3. Sides and sidepocket are a thin wet-in-wet wash of mixed yellow ochre and burnt sienna. The vermiculation is detailed with raw umber.

4. Upper-tail coverts are a base mixture of opaque white and raw umber. The feather tips are detailed with a mixture of yellow ochre, white, and a touch of raw umber.

5. Tail and primaries are a mixture of raw umber and black.

6. The bill is a wash of very thin black, shaded with opaque black, and highlighted with blended white.

7. Opaque black is highlighted with a mixture of white and ultramarine blue pale in the splitbrush. The light area around the bill is a mixture of white and raw umber. White areas of the head and breast are opaque white shaded with thinned ultramarine blue pale in the splitbrush.

8. Cadmium yellow pale and yellow ochre are mixed to provide the eye color.

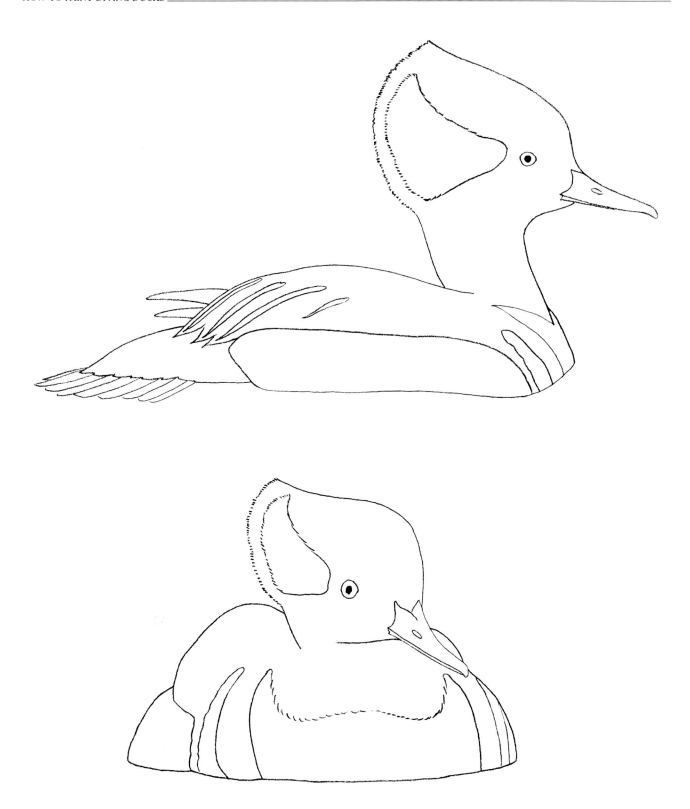

hooded merganser

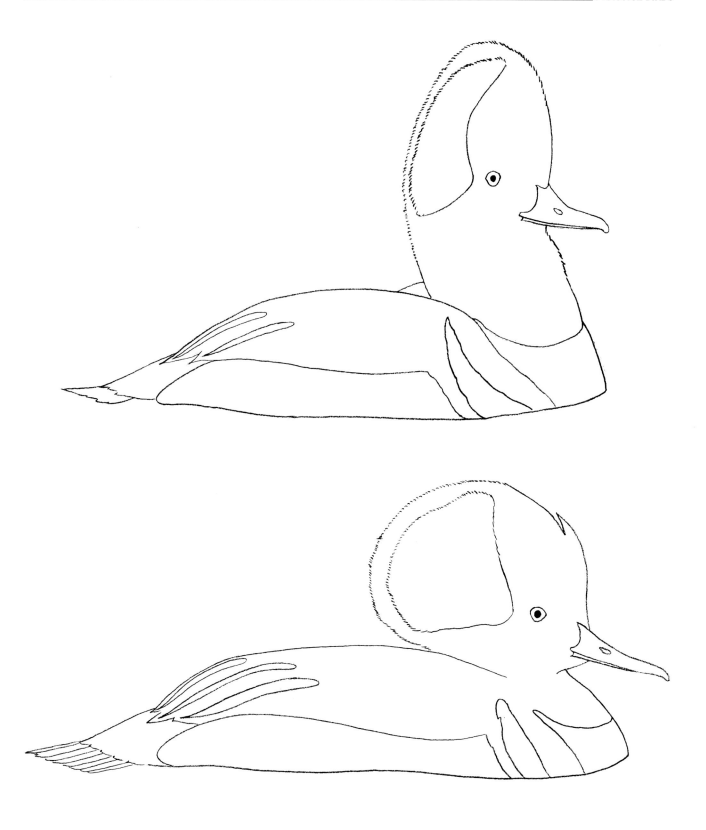

hooded merganser

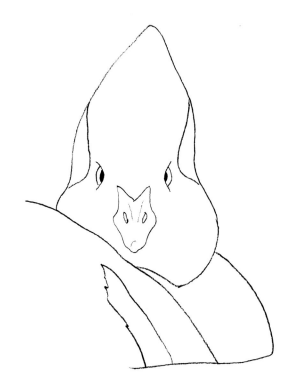

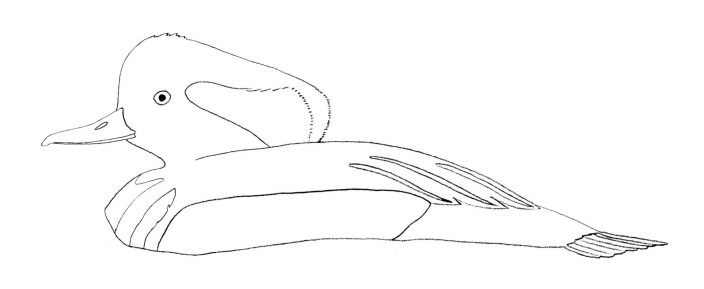

hooded merganser

Common Goldeneye

Bucephala clangula

A flight of common goldeneyes is unmistakable for two reasons: they have distinctive large, snow-white bodies with a dark head and wings; and the powerful and rapid beat of their wings produces a loud whistling sound that has earned them the nickname of whistlers. They are hardy ducks, some staying north on rivers in the worst weather. Those that do migrate south return in the early spring as soon as any open water appears. Courtship rites start as early as February and, as soon as goldeneyes are paired, they start out in search of their favorite nesting site—cavities in old trees or snags. Goldeneyes are good divers; during the nesting season they feed on aquatic insects, crayfish, and plants, and in the winter the foods of choice are crabs and snails.

The male common goldeneye has a dark head that iridesces green and has a large white spot at the base of the bill. The neck, belly, and flanks are pure white. The mantle and back are glossy black, while the large scapulars that hang over the wing are white with a black leading edge. When painting the male common goldeneye, the head, scapulars, back, and wing are painted in a straightforward manner, but creative shading must be used on the white areas to add shape and volume.

Palette: ivory black, white, Pelikan raw umber, ultramarine blue pale, cadmium yellow pale, brilliant green, and sap green yellowish.

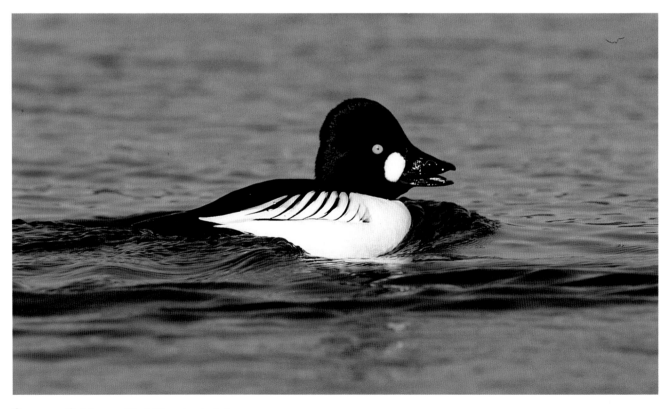

Common Goldeneye (Rod Planck photo)

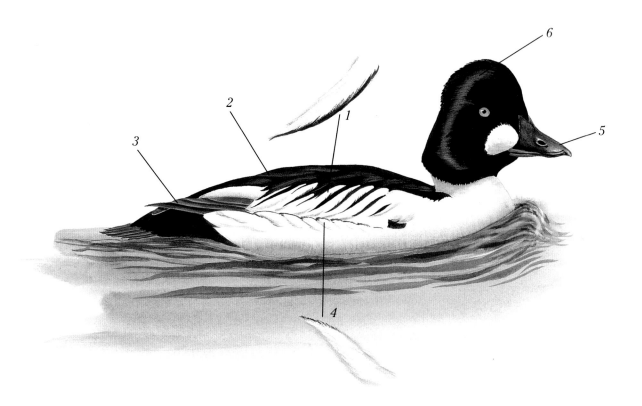

1. Long scapulars are painted opaque white, edged with opaque black, and shaded with thin ultramarine blue in the splitbrush.

2. The dark upper parts are opaque black shaded with a mixture of white and ultramarine blue pale.

3. An opaque mixture of white and raw umber paints the primaries and tail.

4. Sidepocket feathers are opaque white shaded with ultramarine blue pale. The top edge of these feathers is edged with opaque black.

5. The base color of bill is a very thin black shaded with opaque black, then highlighted with opaque white.

6. Brilliant green is painted on the areas to show iridescence. Opaque black is painted on the dark areas and splitbrushed where it meets the green. Splitbrushed sap green yellowish then highlights the brilliant green. Cadmium yellow pale provides eye color.

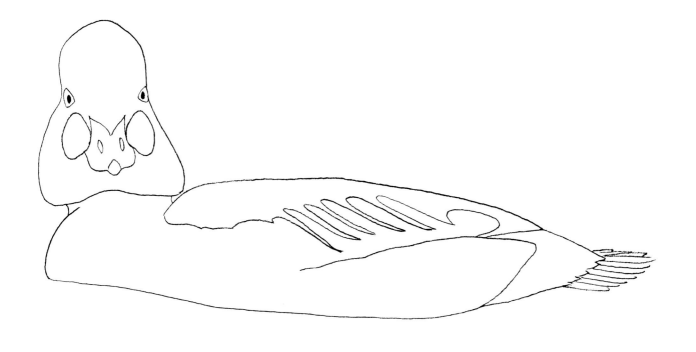

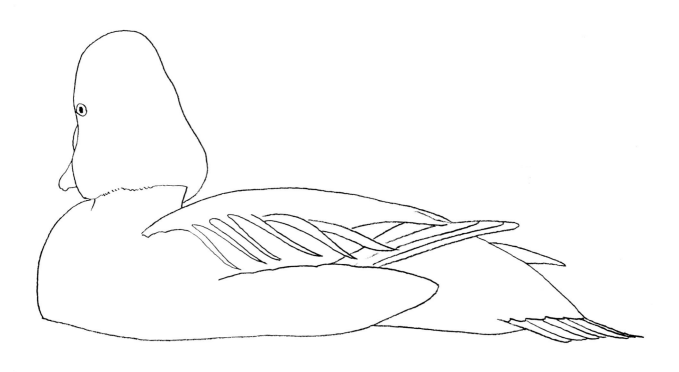

common goldeneye

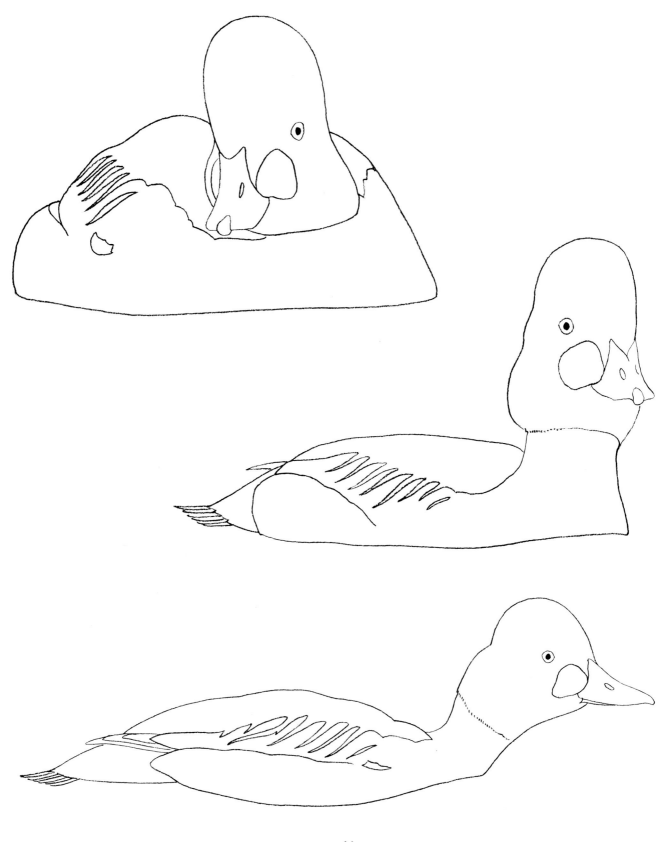

common goldeneye

9
Reference
Material

 A frequent problem that bird artists have is obtaining adequate reference material. Ducks, however, are one of the few species of birds where this is not true; excellent reference sources are available to everyone. Although there is no substitute for observing the color, attitudes, postures, and habits of birds in the wild, other reference sources must be considered because few of us have the ability to remember the field marks, colors, and shape of a bird well enough to paint it accurately. When examining several reference sources, especially photographs and printed material, for a specific species of bird, you will notice wide variations in color for that bird in the different sources. These variations are due to many factors, ranging from the time of day that a photograph was taken (flat midday light or warm afternoon light) to the accuracy of the printer in reproducing a color. (An artist must choose his reference material carefully so he can accurately portray the bird as he perceives it. The following are suggestions for sources of reference material.

Photographs. Most wildlife artists have a 35mm camera and telephoto lens with which to take their own reference photos of birds. Original photos are an excellent source of material; however, they should be used as an aid, not as a crutch. Unfortunately, many artists rely exclusively on photographs that they copy directly. Thus, their paintings are only renderings of photographs—a far cry from original art.

If you don't own or have access to photography equipment, professional photographs and videos of many species of ducks are available.

Nature Centers, Sanctuaries, and Zoos. All these provide the opportunity to watch live birds, caged and free. Be aware that some of the physical features may be affected by captivity. Caged birds may have tattered wings and broken bills from flying against the cage. Also, some of the birds, particularly those at sanctuaries and nature centers, are brought in injured and could have broken wings or other disfigurements that should be taken into account. Some loose yet captive birds are pinioned (wing tip removed) to prevent flight; this means there is only one complete wing. Although this reads like a list of horrors, the birds are well cared for and give an artist the opportunity to closely observe birds that can be difficult to see in the wild. Many individuals have special permits to hold and breed wildfowl; these may provide an excellent reference source. A list of individuals with permits can be obtained from your state conservation department.

Books and Magazines. Both contain art and photographs that may be used for reference; most artists have files of material saved from magazines and other printed sources. There are scores of books on bird art, some of which are good sources of general reference. The rule here is: Don't use another artists work as the *only* source of reference; if an error was made in the original art, you will just perpetuate it. Only use the art of others in conjunction with other reference material.

Preserved Specimens. Many museums and nature centers have collections of preserved birds, such as study skins, mounted in lifelike poses, or frozen, awaiting preparation. If you can gain access to these collections, they are excellent sources of reference material. The anatomical accuracy of mounted specimens may vary greatly, depending on how long the bird has been mounted and the skill of the taxidermist. Again, there are things to remember. As soon as a bird dies, even if it's immediately frozen, it loses, for lack of a better term, its "life force." It becomes smaller as everything collapses, and colors begin to immediately fade, especially in the legs and bill. Most ducks may be hunted legally so they are one of the few bird species

where actual specimens are readily available. If you do not hunt ducks, check with taxidermists or friends who hunt. They will probably allow you to sketch and photograph their trophies.

Carvers' Supply Sources. These firms sell feet, bills, and occasionally heads cast from actual duck specimens. Most also carry books, supplies, and photographs. An excellent reference source.

Reference Books

Audubon Society. *Field Guide to North American Birds, Eastern Region.* New York: Alfred A. Knopf, 1977.

——. *Field Guide to North American Birds, Western Region.* New York: Alfred A. Knopf, 1977.

——. *Master Guide to Birding,* 3 vols. New York: Alfred A. Knopf, 1983.

Austin, Oliver L. and Arthur Singer. *Birds of the World.* New York: Golden Press, 1961.

Bellrose, Frank C. *Ducks, Geese and Swans of North America.* Harrisburg, PA: Stackpole Books, 1980.

Burk, Bruce. *Complete Waterfowl Studies,* 3 vols. Exton, PA: Schiffer Publishing, 1984.

Burn, Barbara. *North American Birds.* The National Audubon Society Collection Series. New York: Bonanza Books, 1984.

Carlson, Kenneth L. and Laurence C. Binford. *Birds of Western North America.* New York: Macmillan Publishing, 1974.

Casey, Peter N. *Birds of Canada.* Ontario: Discovery Books, 1984.

Ede, Basil. *Basil Ede's Birds.* New York: Van Nostrand Reinhold, 1981.

Epping, Otto M. and Christine B. Epping. *Eye Size and Eye Color of North American Birds.* Winchester, VA: Privately printed, 1984.

Gromme, Owen J. *Birds of Wisconsin.* Madison: University of Wisconsin Press, 1974.

Holt, T. F. and S. Smith, eds. *The Artist's Manual.* New York: Mayflower Books, 1980.

Hosking, Eric. *Eric Hosking's Birds.* London: Pelham Books, 1979.

Jeklin, Isidor and Donald E. Waite. *The Art of Photographing North American Birds.* British Columbia: Whitecap Books, 1984.

Lansdowne, J. F. *Birds of the West Coast,* 2 vols. Boston: Houghton Mifflin, 1980.

Lansdowne, J. F., with J. A. Livingston. *Birds of the Northern Forest.* Boston: Houghton Mifflin, 1966.

——. *Birds of the Eastern Forest,* 2 vols. Boston: Houghton Mifflin, 1970.

LeMaster, Richard. *The Great Gallery of Ducks.* Chicago: Contemporary Books, 1985.

——. *Waterfowl, the Artists Guide to Anatomy, Attitude and Color.* Chicago: Contemporary Books, 1983.

Madge, Steve and Hilary Burn. *Waterfowl.* Boston: Houghton Mifflin, 1988.

Perrins, Christopher M. and Alex L. A. Middleton. *The Encyclopedia of Birds.* New York: Facts on File Publications, 1985.

Porter, Eliot. *Birds of North America.* New York: A & W Visual Library by E. P. Dutton.

Robbins, Chandler S. et al. *A Guide to Field Identification—Birds of North America.* New York: Golden Press, 1966.

Saitzyk, Steven L. *Art Hardware.* New York: Watson-Guptill, 1987.

Scott, Shirley L., ed. *Field Guide to the Birds of North America.* Washington, D.C.: National Geographic Society, 1985.

Terres, John K. *The Audubon Society Encyclopedia of North American Birds.* New York: Alfred A. Knopf, 1980.

Tunnicliffe, C. F. *A Sketchbook of Birds.* New York: Holt, Rinehart and Winston, 1979.

———. *Sketches of Bird Life.* London: Victor Gollancz Ltd., 1981.

———. *Tunnicliffe's Birds.* Boston: Little, Brown and Company, 1984.

Art and Carving Suppliers

The list below includes only a few of the many general art suppliers. Most charge a small fee for their catalogs.

Dick Blick
Box 1267
Galesburg, IL 61401

Arthur Brown & Bros., Inc.
P.O. Box 7820
Maspeth, NY 11378

Craft Cove
2315 West Glen Avenue
Peoria, IL 61614

Craftwoods
10921 York Road
Hunt Valley, MD 21030

Christian Hummul Co.
404 Brookletts Avenue
P.O. Box 1849
Easton, MD 21601

J. H. Kline
R.D. 2, Forge Hill Road
Manchester, PA 17345

Pearl
308 Canal Street
New York, NY 10013

Daniel Smith, Inc.
4130 1st Avenue South
Seattle, WA 98134

Wildlife Artist Supply Co.
P.O. Box 1330
Loganville, GA 30249

Woodcraft Supply
41 Atlantic Avenue
Woburn, MA 01888

Books: Old and New

Highwood Bookshop
P.O. Box 1246
Traverse City, MI 49685

Patricia Ledlie
P.O. Box 90, Bean Road
Buckfield, ME 04220

Videotapes and Photographs

The Duck Blind
8721–B Gull Road
Richland, MI 49083

Glossary

Acrylic Gesso. An acrylic polymer emulsion that can be either white or gray-black and serves as a ground for acrylic paints. This is not a true gesso as is used in oil painting.

Acrylic Paints. Pigments that are bound together with synthetic resins or polymer emulsions. Water-based, they dry fast and hard and are not water-soluble when dry.

Binder. A substance used to coat and hold pigment in suspension and to bind the pigment particles together when dry.

Blending. Bringing the edges of two colors together and mixing them to form a smooth transition rather than a hard line.

Blends. The combination of synthetic filaments and natural hair in the manufacture of brushes.

Boards. Paperboards of varying thickness that have a drawing, painting, or colored paper adhered to one side. Illustration, watercolor, and mat boards are all paperboards.

Bristle. Stiff, rigid hairs from hogs and pigs, characterized by split ends on each hair.

Canvas. A woven fabric used as a painting surface. The two most common fabrics are cotton and linen; they are classified by thread count and ounces per square yard. The finest canvas available is made from Belgian linen.

Complementary Colors. Colors opposite each other on the color wheel that, when mixed together, have a neutralizing or toning-down effect on each other; for example, to tone down a bright yellow add a very small amount of violet. The diagram shows a simple color wheel with the primary colors—red, yellow, blue—and their complementary colors. Orange is the complement of blue, green of red, and violet of yellow.

Consistency of Paint. Refers to the viscosity—the thickness or thinness—of paint.

Designers Colors. See Gouache.

Detailing. Painting fine-line details on a picture or carving.

Dimension. In painting, refers to shading that gives shape, separation, or roundness to a form.

Dry-brush. The technique of painting with very little paint in the brush to produce broken, irregular lines or shapes.

Earth Tones or Colors. Naturally occurring in organic pigments that contain clay or silica, they are processed and produce very permanent colors, such as raw umber and raw sienna.

Ferrule. The metal, plastic, or quill sheath that holds the hairs to the handle of a brush.

Filament. Any synthetic materials used in the manufacture of artificial brush hairs.

Filberts. Flat brushes that have rounded ends.

Finish. Describes the surface texture of a paper or board: hot press has a smooth finish, cold press has a medium finish, and rough has an irregular finish.

Flats. Flat brushes with squared ends.

Flow Release. Synthetic or natural (ox gall) wetting agents that reduce the surface tension of paints, increasing their ability to flow evenly.

Frisket. See Masking.

Fugitive Colors. Colors that are unstable and fade or disappear over time.

Gels. Thickening agents added to paints to increase their impasto effect.

Glazing. Painting a thinned color over a dry base color so that the two mix visually and some of the base color shows through.

Gouache *(Opaque Watercolor, Designers Colors).* A water-based opaque paint made with pigments, a gum binder, white, and other additives.

Grading. Creating a smooth transition from pure color to clear or no color.

Ground. A painting surface that serves as an absorbent stable base for the paint; for instance, acrylic gesso is a ground for acrylic paint.

Gum Arabic. A natural gum from the acacia tree, used as a binder for both gouache and transparent watercolor. It also may be added separately to give extra transparency.

Hair. Used in brushes, it is flexible and has a great degree of absorbency. The amount of spring, absorbency, and shape depends upon the type of animal hair used.

Hardboard. A composition-wood fiber board used in the construction industry. In its untempered form it provides a good painting surface when prepared with a ground.

Highlight. To emphasize an area on a painting surface that would catch and reflect intense light.

Impasto. Paint applied thickly to give a three-dimensional quality.

Lifting Off. A substractive technique of moistening and removing dry paint.

Load. The amount of paint carried in the hairs of a brush. A full load is when the hairs are thoroughly saturated but not dripping.

Masking *(Frisket)*. Blocking out an area with liquid masking or paper to form a barrier that does not allow paint to penetrate its surface.

Matte Finish. A flat, nonglossy finish.

Medium. The material with which an artist works or which, used as an additive, alters the materials.

Oil Paint. Pigments that use oils as binders and require solvents and oils as thinning agents.

Opaque. Refers to a paint able to cover a surface so that light cannot pass through it.

Opaque Watercolor. See Gouache.

Ox Gall. See Flow Release.

Ox Hair. Blunt hair from ox ears. Used in brushes, it is dyed red and called sableline.

Palette. Any surface used to hold concentrated paint for paintings. Also the selection of colors used in a particular painting.

Permanence. The degree of light-fastness of a color, the longevity of which depends upon many factors, including ingredients used in manufacturing, light, humidity, pollutants, and so on.

Pigment. Coloring matter derived from natural or synthetic sources. Also used as a synonym for paint or color.

Premixed Colors. Shades of colors mixed by the manufacturer.

Retarder. An additive that slows the drying time of paints.

Round. The most commonly used watercolor-brush shape. The hairs are in a round ferrule and should come to a fine point.

Sable. Hairs in this category are from various members of the weasel family. They are generally characterized by having a fine point, great spring, and strength. Kolinskys are the finest hairs in this group and come from the Asian mink in Siberia.

Sableline. See Ox Hair.

Softening. Lightly brushing along the edge of a hard line to slightly blend it.

Soluble. Capable of being dissolved by a particular substance.

Splitbrush. Fanning the hairs of a brush until they split apart.

Tipping. Touching only the tip of a brush to a surface and lifting or dragging it to produce various marks.

Tone. General coloring of an area.

Tooth. The texture of a surface, whether paper or gesso, that influences how the paint will appear. A smooth surface has less tooth than does a rough surface.

Transfer. The act of transferring or duplicating a drawing from one surface to another.

Transparent. Refers to a paint that allows light to pass through it.

Transparent Watercolor. A water-based paint with a high concentration of finely ground pigments in a gum arabic binder.

Visual Weight. The perceived impact, brightness, and depth of a color.

Wash. The application of paint thinly or transparently: may be a continuous (even) tone, graded, or glazed.

Watercolor Paper. Handmade or machine-made, a variety of fibers are used in its manufacture, including wood pulp, bark, cotton, and combinations of these. The finest papers are made from 100 percent cotton fibers.